THE MAN WHO LOVES GIANTS

DAVID SHEPHERD was awarded the order of
the Golden Ark by HRH the Prince of the
Netherlands for his services to conservation in
Zambia and to Operation Tiger. He was also
awarded an honorary degree of fine arts by the
Pratt Institute in New York. Married with four
daughters, he lives in an Elizabethan farmhouse
in Surrey.

'Regrets? There are simply not enough hours in
the day. Life is so exciting and every minute of it
has to be lived.'

'Ambitions? I must live to be at least 150 years
old to be able to pack in everything I want to do.
And right up to the end I hope that people will
want my paintings.'

The Man Who Loves Giants

An artist among elephants and engines

David Shepherd

CORONET BOOKS
Hodder and Stoughton

Copyright © David Shepherd

First published in Great Britain 1975 by
David and Charles (Holdings) Limited

Coronet edition 1977

Printed in Great Britain for
Hodder & Stoughton Paperbacks,
a division of Hodder & Stoughton Ltd.,
Mill Road, Dunton Green, Sevenoaks, Kent
by Hazell Watson & Viney Ltd.,
Aylesbury, Bucks

ISBN 0 340 21834 7

To Life

with acknowledgements to all the marvellous people who have helped me, and made it so exciting — to Avril and my daughters Melinda, Mandy, Melanie and Wendy — to Linda who typed the manuscript — to Robin who taught me to paint — and not forgetting my mum

CONTENTS

Foreword by James Stewart

It certainly can be said that David Shepherd is one of the fine painters of our time. In addition to this I have noticed two things which to me make his talent remarkably unusual. David Shepherd has become most widely known for his painting of wildlife—especially elephants. The other thing is his determination that the steam locomotive shall survive.

Taking the elephants first. I think that there is something that has not been equalled in a Shepherd canvas of his majestic elephants (jumbos to him) advancing over the beautiful East African plain through golden grass and familiar acacias, under a sky laced with remarkable clouds, and I believe David can accomplish this mainly because of his admiration and complete respect and love for this great creature and its habitat. The sale and donation of Shepherd paintings has been an enormous contribution to wildlife conservation throughout the world.

Now for the steam engines. David simply refuses to let them die. He started by painting them but became impatient and bought his own steam locomotives and a railroad to run them on, a short one but a railroad none the less.

So it's a comfort to me to know that my great-grandchildren, in their world which may not see either elephants or steam locomotives, will still be able to look at a David Shepherd painting and say 'great'.

James Stewart

Beverly Hills,
California

1 SOUVENIRS OF BOYHOOD

Beginnings, and terror on horseback—my first tiger—the war, and a small boy's excitement—to Stowe, and indoctrination with the beautiful things in life—and I paint birds, on plasterboard

Painting elephants in Cornwall is, I suppose, a bit odd. And people consider me an eccentric, collecting full-size steam locomotives. But it is a fanciful idea that I sat straight up in my pram and started drawing jumbos.

I was always rather a nervous little boy, and led the usual sheltered middle-class life, never really wanting anything. My memories of the riding lessons then obligatory for middle-class children confirm this. I was usually given the lazy or bloody-minded pony—the one that lagged behind and finally came to a halt: down would go its head, and the wretched thing would start eating. There was nothing I could do except scream for help as I began to slide down its neck. It would then, of course, wake up and shoot off at about ninety miles an hour to catch up with the rest of the class, with me hanging on for dear life.

I always seemed to get the pony with the weak bladder. I shall never forget the misery and embarrassment only a small boy can feel when—in the middle of a main road— my pony stopped to pee, with the traffic stretching away interminably into the distance. The shouting riding master terrified me : 'You are meant to stand up in your stirrups when a horse urinates.' I believe there is some technical reason why this helps the horse, but it did little for me. The riding instructor seemed determined to kill me off at an early stage. To me, the ponies appeared far too big, and the jumps even bigger. And I was expected, for some

strange reason, to jump without holding on to anything, and usually without a saddle. So I always fell off.

There are of course happy memories as well. I remember being sick in the train on the way back to London from Maidenhead, but at least it was hauled by a Great Western Railway pannier-tank. My railway memories have to start somewhere!

I don't really know when any artistic inclinations began to show themselves. There certainly isn't much art in the family history — my father was in advertising until the war, then went into the army. Although my mother hotly denies it, I had no particular artistic talent, but when I was eight I did win a children's painting competition in the *Nursery World*: it required the enormous skill of filling in with coloured crayons the printed outline of a tiger. The prize was a book token, but the incident has a nice significance now that I am so wrapped up with wildlife conservation, and since, in 1973, I managed to raise £127,000 with one painting to help save the tiger, now so desperately in need of protection. The lady who awarded me the book token is now the editor of the *Nursery World* and she came to the party to celebrate.

When the war clouds were gathering, my brother, sister and myself, like so many other children, were rushed away from likely invasion or bombing. In our case, the destination was an enormous and beautiful country mansion in Scotland, right up in the foothills and surrounded by endless forests. Peningham House was owned by my great-uncle, never very tolerant of grubby little boys. Indeed, we only saw him for a brief few moments before dinner. We used to go out all day into the hills with the game keepers and estate workers. It was a fabulous life, although, looking back, it had a thoroughly distasteful side in that we went out snaring rabbits. We were back in London after a mere two weeks but the visit left an indelible

March 18, 1943

For the Children

After Tea-Time

DEAR CHILDREN,

You will remember I told you last month that a new series of nature articles would soon be commencing, and that they would be about insects. I think you will be very interested to read below how mother insects look after their babies.

David Shepherd sent in a very good colouring of the tiger picture and the prize has been awarded to him. David is 8, and comes from " Normandy," Northcliffe Drive, Totteridge,

My first brush with a tiger

impression on me. Peningham, by the way, is now an open prison.

The most impressionable period of my childhood was as a young schoolboy in the early 1940s; to a kid the war

was just madly exciting. This is probably why, today, I have such a passionate interest in World War II and a feeling for those years which has given me the enthusiasm to paint so many pictures for the services. We were living in Totteridge, in North London, and during the bombing at night my mother was driven demented trying to keep us down in the shelter when we insisted on rushing out to the lawn in our pyjamas to watch the Dorniers and Heinkels caught in the searchlights overhead. The next morning we would pick up the pieces of shrapnel—my first collection of relics. I still have a lot of it in a box with all my precious wartime relics, bits of bomb casing, fuses, unexploded shells and bits of crashed German aircraft. They had, and still have, a distinctive smell about them—be it oil or whatever. The Imperial War Museum has a Jumo engine from the Messerschmidt in which Hess flew to Britain; every time I visit the museum I go up to the engine and *smell* it — and it's that very same smell.

Towards the end of the war, after we had moved to a lovely house at the edge of Epping Forest, a doodlebug crashed nearby. My brother and I dashed up just afterwards and loaded a massive piece of jagged metal into the boot of the car. This was a treasured possession to both of us; unfortunately, when he moved away many years later, we left it behind to the scrap merchant. That clearing in the Forest, with the shattered tops of the beech trees, can be seen to this day.

On one particularly bad night of the blitz a whole load of incendiaries was dropped in the field next door. At daybreak my brother and I beat the police to the scene and spent a dangerous but happy hour or so picking up lots of tails and pulling one unexploded bomb out of the hole it had made. What a menace little boys must have been to the authorities! But we had a good side to our natures. We put on an exhibition of all our relics in a local school, the

star attraction being a battle-worn Italian flag, hauled down under fire from Catania in Sicily and given to us by an officer billeted nearby. We raised just over £60 to help buy a Spitfire.

At school we would swap souvenirs, maybe pieces of landmine parachutes for pieces of crashed ME109. One particularly offensive bully there, tall and blond and broad —he should have been a member of the Hitler Youth— swindled me of all my best Dinky toys with some rubbishy story, and for once my brother and I determined to get our own back. So we stripped my bicycle of its little leather saddle-bag and, taking great pains over many evenings, carefully wrote 'Achtung!' with a hot poker on to the leather. Our Hitler Youth friend was duly convinced that this was a German motor-cycle rider's despatch case and we retrieved all our Dinky toys.

We were experts at aircraft recognition and probably could have taught the Observer Corps something. Captured German aircraft were put on display to raise money during Spitfire Week, and we would queue to sit in their cockpits. By the time we had stepped down, with bulging shapes under our shirts, more damage must have been done to the aircraft than even the RAF had wrought.

To get us away from the bombing, my parents decided to send my brother and me up to Stowe school, in the unspoiled wilds of Buckinghamshire. The breathtaking beauty of the place was bound to brush off on anyone with artistic inclinations, however latent, and shaped my future life far more than I could then know. To this day I think it is physically one of the most fabulous places in Britain, with its hundreds of acres of magnificent trees, sweeping lawns and vast lakes. Art, for me, was born at Stowe—but for the wrong reasons: because anything was better than the torture of playing rugger, I used to invent every possible excuse to get into the art school. So I did perhaps

have more opportunity than most to paint. The art school was more like a club, where the more artistic among us donned yellow waistcoats and went faintly Bohemian on Thursday afternoons. I used to paint ghastly pictures of birds on plasterboard—a foretaste of others that, in spite of their incredible incompetence, were to pay my fare home from Africa in just a few months' time.

Musically speaking, Stowe was a marvellous place to be. Our music master had the unique distinction of being joint-master of the Grafton Hounds: he would hunt a couple of days a week in the season, drive back to Stowe and take a couple of music lessons, probably play the organ at evening chapel, and then dash home to clean his tack. Out of his own pocket he paid for the whole of the London Philharmonic Orchestra to come down and play in the school gym; Moiseiwitsch was the soloist in the 'Emperor' piano concerto. Heaven knows what he must have thought of the acoustics, and the rope ladders dangling above his head! (Actually he was rather cross about it.)

In my studio today I cannot paint without either Mahler or the Beatles pouring full blast from my stereo. In the morning, when I am at my most productive, light classical or pop music keeps me happy; after lunch, however, and in the summer particularly, my productive capability drops dramatically and an opera or some other long work will keep me going throughout the afternoon and stop me sitting down; something like 'Madame Butterfly' or Elgar's 'Dream of Gerontius' is ideal. After tea I begin to wake up again, and go over to Glenn Miller, Count Basie and Frank Sinatra. Apart from all this, Bruckner turned up at full volume helps to drown the noise of the juggernauts which now take a short cut down the lane past my studio. But with some of my favourite music, such as Mahler's great 'Symphony of a Thousand', I can't paint at all: I have to put my palette down, and the great finale leaves me

emotionally wrung-out. This intense feeling for music was born at Stowe.

Another memory of Stowe important to me now is that of the old Hawker Hart used for instruction in the workshop yard. We boys pulled pieces off it and were taught the rudiments of aircraft engineering. That lovely aeroplane would be worth a fortune today; one so often learns too late.

2 TO AFRICA FOR THE FIRST TIME, AND DISILLUSIONMENT

God's gift to the Kenya National Parks? — by flying boat to Africa, with lionskin and bicycle — homesickness, but I see my first jumbo — I work in a hotel and I paint more birds on plaster-board — home again, to live as a bus driver or starve as an artist

At the age of nineteen, I left Stowe with just one dream in life : to be a game warden in Kenya. My only qualifications were a Higher School Certificate in Geography and English, and the extraordinarily arrogant idea that I was God's gift to Africa's National Parks. I would go out to Kenya and knock on the door of Mervyn Cowie's office — he was Chief Game Warden in Kenya at the time — and say, 'Here I am — can I be a game warden?' He would say, 'Yes, how marvellous. Here's a job.'

This obsession for being a game warden must, I think, have begun with the books I read as a kid by the so-called pioneers who 'opened up Africa'. Nowadays their stories leave me with a strong feeling of disgust and revulsion; most of them are one long tale of slaughter from cover to cover. 'Only shot eleven elephants this morning — generally a bad day' or 'found three fine male rhinos, downed the first two with two shots, the third one was more trouble.' It is because these early hunters shot everything that moved, without a second thought, that we have now to think so desperately of wildlife conservation.

Anyway, my dad did nothing to discourage me from being a game warden in Africa, adopting the generous philosophy that if that was what I wanted to be, he would not stand in the way. The journey itself was a most roman-

tic affair. The BOAC 'Solent' flying boats of those days took off from Southampton Water and flew to strange places like Alexandria, landing in the Mediterranean, and Khartoum, where they landed on the Nile. There was nothing quite like flying in a flying boat. As you were gently let down, you could look out of the window under the wing and watch the first spurt of spume as the wing-tip float touched the surface, and then a great surge of water before the plane came to a halt. By the time I arrived on Lake Naivasha, even this sensation did not appeal—I had been as sick as a dog for thirty-six hours. In those days an aircraft did not fly over any banks of cumulus but went straight through the middle, and it did not help my stomach to be sitting next to a chap who ate pork chops most of the way.

But here I was, on a beautiful African evening. Everything was new: the air was new, the birds were new and the whole landscape was new. There is a certain magic about Africa which bites the first time it is experienced and I knew I was falling under its spell as I walked from the hotel down to the lakeside that very first evening.

Through an uncle of mine, a coffee farmer had been told about me and astonishingly had decided to take me under his wing. I am appalled now to think how useless I must have been to him. He collected me next day in his pick-up truck and drove me, it seemed at the time, right into the middle of nowhere, into the 'White Highlands'. Here, there was no game at all; it had all been shot off years ago.

I knew nothing about coffee. I was miserable. Up till now the thought of homesickness had never occurred to me, but within twelve hours of arriving on this remote farm, it hit me like a sledgehammer. I had no mobility and felt imprisoned, and I remember writing hysterical letters to daddy pleading to come home, then counting the

minutes until the reply came; I almost made myself ill. In the meantime my baggage arrived. I had left England fully prepared to spend five years in Kenya and the thing which fills me with horror and pain is the fact that my father, believe it or not, allowed me to fly out all my worldly possessions—and paid the bill. While the bewildered farmer looked on, the enormous crate was offloaded from the truck. I unpacked my bicycle and all the other extraordinary things which I had so irresponsibly brought from England. I wonder if it ever occurred to any of us that there are bicycles in Africa—quite a lot of them in fact? I had even imported a moth-eaten lionskin which I had bought for a pound in a junk shop in Buckingham!

The novelty and excitement of starting out on a great adventure fell off me like a cloak. The transition from cloud-cuckoo land to the realisation that I was a very square peg in a very round hole a long way from home shattered me. The idea was that I should work on the coffee farm (nobody asked me if I was interested in coffee —I wasn't) to fill in time until I could get a job as a game warden. The coffee farmer was a fairly hard man; I was totally useless to him and he told me so, fairly but in no uncertain terms. And to see me weeping at the age of nineteen and a half did not improve his frame of mind either.

Finally, the reply came back from my father. 'No, you bloody well stay there now. We've spent all this money getting you, your bicycle and your lionskin out to Kenya and there you stay for six months at least.' My world fell apart. But of course he was right. I stayed on the coffee farm for a month. It must have seemed a great deal longer to the long-suffering farmer and his wife.

The day came when I was to go down to Nairobi to see the National Park administration. The visit was to be short and not very sweet. After all, why should they give

me a job as a game warden? I hardly knew the difference between a zebra and an antelope. I had never been out of England before, and there were plenty of bronzed young men born and bred in Kenya waiting for the opportunity.

But Mervyn Cowie did give me my first chance to see a jumbo. Tuffy Marshall, then a warden in the Nairobi National Park, was going down to Amboseli the following day with Len Young, a photographer for the East African Railways, and I was offered a lift. We drove out of Nairobi and there, on the horizon, I caught my first glimpse of the 19,000ft glistening white snowcap of Kilimanjaro a hundred miles away, hovering like a mirage over the landscape.

We spent a couple of days down at Amboseli. It was raw, unspoiled Africa in those days—now it is a fully fledged National Park, full of people and the paraphernalia that have to go with them—notice boards, tracks, lodges, toilets and all the rest of it. The three of us slept under the stars with only a mosquito net. And lions walked through the camp during the night. We found their pad marks the next day in the dust beside our beds.

Those were gloriously happy days, driving round in Tuffy's Dodge power wagon. And I find it hard to describe my feelings at seeing for the very first time an African elephant in the wild. I had made childhood visits to zoo or circus, but this was different. I was on my own two feet, and there were two hundred elephants in front of me; it was an enormous herd. Tuffy took Len up really close, to get some good photographs. Possibly I would rather have gone up with them, for I was left alone, on foot. And it was an exhilarating feeling. I don't know whether I was afraid. I imagine not, as it was all so new and exciting, and I was very, very green, knowing nothing about wildlife whatsoever. But I know I will never forget the sight of those two hundred elephants browsing completely free and undis-

turbed. I felt small, very small indeed. Over all this hung, almost like magic, that breathtakingly beautiful snowcap of Kilimanjaro. How that mountain has drawn me back to Kenya — 'my' mountain! I had been hooked by the incurable disease of Africa.

Back in Nairobi, I had to set about trying to make myself useful to someone. I answered an advertisement for a hotel receptionist and got the job. I can't imagine why. In fact the post had already been filled, but Philip Mumford, who owned the hotel at Malindi, evidently liked my face and offered me £1 a week and my keep. I had not been in Malindi, on the Kenya coast, for more than an hour when I was told to take a party of Americans out goggle-fishing. I had never been goggle-fishing, but nor had they. The bluff worked; in fact they were most impressed. I honestly think they believed I had been in Kenya all my life. And I had not even unpacked my suitcase!

They were happy days at the Sindbad Hotel. I designed cinema posters and generally made myself useless to everybody. But the Mumfords were tolerant and are still very dear friends of mine. Besides, Malindi was just a small coastal town, totally unspoiled, very Portuguese, with a handful of European residents. The mass package tours from Frankfurt were still, mercifully for Malindi, a good many years away. Long walks up the coast gave me a marvellous Robinson Crusoe feeling, as if on a beach that had never been trodden by man: in all probability, a lot of it hadn't. It was, and still is, pretty remote country north of Malindi, no buildings, people or anything else at all — virgin beach all the way up to the Red Sea.

I had to drive the rather lethal American pick-up truck to Mombasa once a week to collect stores. The road was diabolical. On one occasion one of the wheels came off — I suddenly saw it running alongside me! Needing a Kenya driving licence, I took a driving test in Malindi: it con-

sisted of driving around the block, once, in the middle of the town. I don't think the chap minded whether I was competent or not.

But I was getting nowhere, and had to start some sort of career. To make amends for my father's generosity, I decided to pay my passage home, so I began painting bird pictures again. It was hilarious really to be sitting on the beach of the Indian Ocean working away at mallards flighting in over the Lincolnshire Fens against a very badly painted moonlight. Every time I dropped one of the pictures the corners fell off, plasterboard being the only thing I could get to paint on. But I shoved all the pictures up in the hotel and managed to sell seven of them for £10 each, which paid my passage, tourist fare, round the Cape by Union Castle. The people of Malindi must have been culture-starved in those days.

Once back home, I had to sort myself out. My one ambition in life had come to nothing. I had had a good education and might be quite a nice chap, though I could see that in Kenya I'd been no more than a sponger. It seemed that I could either live and eat as a bus driver or starve to death as an artist—'bus driver' covering just about every job which would pay the bills but give me little satisfaction. (I might have survived as a bus driver if I'd been allowed to drive where I liked.) To take orders from somebody else was not appealing. Starving as an artist seemed better—not the starving but being an artist. I assumed, like most people do, that artists inevitably starve to death in a garret. So my dad, bless him, no doubt hiding some reservations, said, 'You must still have some sort of training—you'd better go to that place called the Slade.' The Slade was the only art school we had heard of. I trundled off to London with loads of plasterboard, and unspeakably badly painted birds flying in all directions, and entered for their entrance examination. A few weeks later

23

a letter came back: 'Failed, talent lacking'. Or words to that effect. The second choice in my life had fallen apart.

In spite of my hatred of cocktail parties, I was at one in London shortly after this and there met Robin Goodwin; that evening changed my life. Here was a fully qualified, hard-working, sensible artist; he didn't even have a beard. Robin was actually earning a very good living simply painting pictures. For some extraordinary reason he listened to my whole tale of woe. At his invitation, the following morning I trundled off yet again with my plasterboard, to his magnificent studio in Tite Street, Chelsea — Sargent and Augustus John had painted there.

'I've never taken any fulltime students, and I don't see any reason why I should start now,' he said, and expressed amazement that anybody could paint quite so excruciatingly badly — even on plasterboard. But he must have recognised a flicker of talent somewhere which had been missed by the Slade. 'Do you want me to teach you?'

3 ART TRAINING AND LONDON
ADVENTURES

Learning art the hard way—frightening moments on Westminster Bridge—coloured footmarks down Whitehall—debutantes at ten—no nudes in Esher—the madness of a Tech—Embankment encounters and my first sale—Academy bureaucracy, tin cans and chair legs

My training was to follow the tradition of the past, when pupils were apprenticed to the great masters. The student then went through the mill, learning the hard way, which is always the best. The world does not owe anyone a living just because he is an artist, but too many art schools today fail to train their students adequately, or teach them to treat art as a business. Not all even teach them to draw. Robin Goodwin had been to one that did but he had had to sit through endless lectures on the history of art when he was longing to start painting: learning about when Botticelli panited his gorgeous naked women is absorbing enough at the right time, but is little practical help to a young man impatient to earn his living from painting in the 1950s. You can learn it all from a text book anyway. The pity of it is that so many of the young people who are discouraged have genuine talent—far more than I had. During their three or five years at art school they are encouraged to 'express themselves'—which probably means throwing paint at the wall—and they leave, like sausages out of a machine, with their teacher's diploma, to discover that there are not enough schools with vacancies for art teachers. Yet all I myself could offer a young girl brought to me for advice on where to train was, 'Try the local art

school'; her final disillusionment with the training on which she had started was to be told simply, 'Work up a project with sunglasses and an egg.'

Robin Goodwin, remarkably, knew exactly how far to drive a student without quite breaking him. In the first few minutes of my first morning at his studio, I felt I had already had a year's training. I had, and I burst into tears. Robin metaphorically shook me by the scruff of the neck. 'You're kidding yourself if you imagine that you can paint only when you feel like it. And don't talk all that rubbish about painting from your "innermost self". The Electricity Board doesn't give a damn whether you're painting from your innermost self or from anywhere else. They want their bills paid. You've got to get into your studio at nine in the morning, even in the winter when it is so dark outside that you can't see your easel or canvas. You've got to paint all day long, until the light fails — Sundays as well. Treat it as a business. If you're prepared to accept all this, I'll teach you. But if not, bugger off now and stop wasting my time.' More tears. But I have him to thank for my success and I grew up almost overnight.

I firmly believe that this is the only way to teach anybody to succeed at art or anything else. Just because one is fortunate enough to be creative, whether in architecture, music, painting or writing, there is no excuse for laziness — the harder you work, the faster you will get to the top. 'You have to eat, sleep, and think painting twenty-four hours a day.' This was so intensively drummed into me in those early days that I do it automatically.

The initiation was over. 'Right, come on out, I've got a commission to paint Westminster Bridge and you're coming too.' I had never painted in public before. Feeling like an animal going to slaughter, I followed Robin on to a bus, carrying my shining new easel and a canvas. We arrived at Westminster Bridge, and the paralysis crept slowly over

me. 'Put your easel up there.' It was right by the bus stop! 'Get on with it. And get Big Ben the right shape while you're about it — precious few artists do.' Within minutes he was painting away, oblivious of the thronging city around him. My morale was sinking, and I watched apprehensively every time a bus came by — about forty people would glue their eyes on Robin as they travelled past. But he took no notice. I fled. I remember running down the steps behind County Hall and hiding behind the wall. There I set my easel up; the large stone blocks in front of me hid my view of Big Ben or anything else, but at least nobody could see me. It did not work. 'Come on up here. Don't be gutless.' I had no choice, but I was too frightened to touch the canvas for almost three days.

Throughout that summer, we did painting after painting — in Brompton Square, Shepherd Market, the Docks, Cherry Garden Pier near Tower Bridge, Westminster Square, the Embankment and Whitehall. Gradually I was getting used to painting in public. And I was learning, the hard but proper way. You see life, too, if you set up your easel at ten in the morning and stay there until six in the evening. In Westminster Square we were besieged by little cockney kids — it must have been the school holidays. We sent them with messages backwards and forwards between us, and they entered into the spirit of it with typically good humour. 'That artist over there says yours is the best, guv.' I would retort, 'Oh, absolutely not. I'm only the student and I'm learning. His is the best.' So back they would go across the square and this went on all day.

Down on the Embankment, Robin and I became engrossed in painting the lovely old Victorian lamps. And that was certainly the way to learn to draw. We would spend a whole morning painting the very detailed little fiddly bits on the lamp and then a bus, rushing past a few feet away, would create a dust storm and the painting,

27

within a matter of seconds, was covered with a layer of bus tickets, dead leaves and all the other paraphernalia of a London pavement. Or it was some fat fly taking his Sunday walk right down the sky and dragging his feet all over the picture's best bits; and the next day was spent picking all the bits of muck out of the wet paint with a palette knife. However, it was all part of the fun.

Our misfortunes were obviously witnessed on one occasion by a woman looking out of her window. I was painting away, half frozen, when the woman brushed past me and I heard her say, 'When you've finished with it, leave it under the seat.' There was a beautifully packed basket with a cold lunch, complete with knives and forks, salt and a thermos flask of hot tea. I never did find out who that dear lady was.

The crowds were the greatest hazard. If we set our easels up in a place like Whitehall in fine weather, about two hundred people would be around us for most of the day. After all, it was free entertainment. They used to come out particularly in the lunch hour. And the tourists —Robin and I must feature on miles of movie film. And when they filmed us they would insist on standing in front of us so that we could not see what we were painting. Bystanders would stand right behind us making rude comments in some unintelligible language. Sometimes they came so close that we could smell their bad breath down our necks. We would wait until they had their toes right under our heels and then step back very heavily, wiping our palettes on their suits. I suppose it was a bit naughty really : but some were insufferable. On one occasion I dropped my palette face downwards on the pavement; it left thirteen little pyramids of different-coloured paint sticking on the pavement and throughout the day people were walking backwards and forwards through them. By 6 o'clock there were beautiful coloured footprints all the

way down to Westminster Square and in the other direction up to Nelson's column. They're probably still there.

Of course, we came up against the inevitable bureaucracy. I believe there is some strange rule, going back into the mists of time, that if your easel has three legs you must have a permit, and if it has two you needn't. It was put to the test when Robin and I were painting outside Buckingham Palace, and some wretched little official said, 'Do you realise you are not allowed to paint here without a permit?' There is a strange contrast between English and French attitudes towards the artist. If you set your easel up in the middle of the Champs Elysées in Paris, they would divert the traffic round you rather than disturb an artist and his work. Robin and I developed a technique which usually worked. On being asked to move on, or whether we had a permit, we would adopt a totally vacant expression, jaws dropping, and the questioner would decide that we were nut cases and wander away. After all, with artists what else does one expect? I must have been arrogant even in those days. Once, as I painted away, I noticed an immaculately dressed young woman hop out of a car with a cameraman. He proceeded to set up a tripod and I realised that she was a model: but I was hanged if I was going to be a blur in the background of a photograph in *Vogue*!

Robin and I must have painted some fifteen pictures that summer in Shepherd Street and Shepherd Market. Before the planning people and property developers wrecked most of that area with faceless modern office blocks and parking meters, this part of Mayfair resembled the centre of a little country town. It was a delightful backwater full of quaint charm, a few yards away from the hurly-burly of Piccadilly and Curzon Street. Shepherd Market was, of course, still a red-light district, and Robin and I had enormous fun with the local ladies. They en-

joyed watching us paint, and in the mornings in particular —presumably their least busy time of day— we would have half a dozen or more of them around us. Then a customer would come up and try and procure one of them in particular. It was always amusing to see the embarrassment on his face, as he tried to sort her out from the crowd. I sold twelve paintings of the Market straight off my easel before they were finished. The tourists would buy them to take back to the States, where they were able to tell their friends that they had actually seen them being 'genuinely hand painted'. The fact that sometimes the buildings were floating on a white canvas and did not have any pavement underneath them did not seem to worry them.

As Robin was a specialist in marine subjects, we got permission to go down to the London Docks and paint. The Port of London Authority gave us a permit to go wherever we wanted at weekends. On one particularly windy day we were painting on Cherry Garden Pier, which juts out into the Thames near Tower Bridge. Nothing on God's earth could save your canvas if a gust of wind caught it. Robin was the unlucky one. He last saw his picture bobbing merrily on its way down to Greenwich accompanied by some of his best brushes. A marvellous lady called Greggie used to come and paint with us on Sundays and came down to the Docks with us. Once, in the depths of winter, we were sticking it out, almost frozen solid to the ground and utterly miserable. Neither Robin nor I would give up first; we were each determined to outdo the other in some sort of stupid determination to be frozen to death. It came on to snow and hail and rain all at once, and the only place to shelter was in the 'Gents' urinals. Greggie did not flinch—after all, it was a bit of cover.

They were happy, intense and brutal days with Robin. He had told me on the first day that he was only going to comment on the bad things I did, and never intended to

say anything good about my work. I gradually became oblivious to this and resigned to the fact that I would never do any good painting at all. On many occasions I burst into floods of tears and rushed down the studio stairs to the street in a screaming rage. I would be on the point of driving away for ever in my little pick-up truck when the studio window would open and Robin would yell, 'Come on back, you gutless idiot—I'm still teaching you so you must be worth teaching.' This was probably the only kind thing he would ever say to me, but it was enough to bring me back. There is little point in telling a student he is marvellous all the time. And I wasn't anyway.

I had been idle during one summer holiday, building a model railway when I should have been painting. I had produced only one picture, and thought it was rather good —a Javelin Jet fighter zooming upwards into an impossibly blue sky. I showed it to Robin with pride. There was a long silence. Then, 'To look at that you'd think you'd never had a lesson in your life.' It was hurriedly painted over, because Robin told me never to waste a canvas, and later it became a not unreasonable picture of Trafalgar Square.

I lived every commission that Robin did. He painted a large number of portraits—of one débutante after another, a feat of sheer endurance. The girls came along at 10 in the morning, dolled up in evening dress. Most of them had faces rather like puddings and were accompanied by 'Mummy' to make sure that we behaved ourselves. Small risk to them—with faces like puddings, at 10 in the morning! 'Mummy' used to say to Robin, 'Make Angela prettier than she really is, won't you?'

So many girls of this age, in my view, have little character in their faces anyway, and such an exercise does not justify the effort from either sitter or painter. It seems to me far better, cheaper and quicker, for a photographer to

do the job. But, if 'Mummy' was safely out of the way, Robin used to chuck the girl a sweater and tell her to get behind the screen and let her hair down and take her make-up off. If she accepted this treatment, the end result would probably be far more satisfactory.

Sometimes Robin had to go to the sitter's home to take on the assignment. This was even worse. I rapidly concluded that it is a complete waste of time to paint young children in oils. The kids used to sit there shivering with cold or fright, or both. Either way, it ended up in screams all round and general chaos. If 'Mummy' came in half way through, then all hell was let loose. The only way to get a really good result in painting a portrait is to have complete application by both sitter and artist. You cannot expect an eight-year-old to sit all day long without moving a muscle; most adults couldn't do it. Another anxiety was that we both had a habit of dropping paint on the floor occasionally — and paint on the curtains was never popular.

One of the problems I had when training with Robin was the lack of opportunity to do life drawings. An artist cannot really afford to have a fulltime, professional model posing for him alone in the studio. However, Robin did manage to get a couple of generous girls to come in to pose for us purely for nothing. This gave me the opportunity to paint one of the few nude pictures which I felt was fairly reasonable as a painting. About that time I was having introductions to various businessmen who might be potential buyers of pictures. One lived in Esher, right in the heart of the stockbroker belt. I loaded all the pictures into the back of my car and drove to his house. I showed him landscapes and pictures of London, and then his eyes fell on my little nude. He grabbed it with both hands and ran triumphantly into his dining room, where he hung it on the oak panelling. I must say that it looked rather super; it could have been painted just for that setting. But his wife

would not let him have it: 'My dear, how can we possibly eat our dinner with that in the room?' Considering that all I was giving away in this simple little painting exercise was a glimpse of one innocent little breast—it was in fact a back study—this seemed a particularly fatuous statement.

Because of this lack of opportunity to draw from life, Robin advised me to go to Guildford art school. So I paid my 11s a term and went to evening class once a week, after being warned not to listen to a word that the instructor said because he might undo in ten minutes all the training I was having. The models themselves were hardly inspiring. One male model stripped to his birthday suit and all one really noticed were his purple toe-nails.

One evening, as I was quietly sketching a nude, with my ears duly stuffed up with cotton wool, along comes Mr Z with beard and sandals flapping. 'Can't you see that that lacks any vitality?' Exactly as Robin had forecast, he dug his palette knife into my pure cadmium orange and, with about eight bobs' worth on the end of the blade, stepped back a few paces and then literally took a flying jump at my canvas. My picture exploded in a great burst of pure cadmium orange on one breast. Stepping back again, carried away completely with the exhilaration of his own efforts, he said, 'Now, can't you see that has given your painting life!' I scraped it all off and continued painting as I had been taught—searching for subtleties. Any fool can squeeze pure colour like toothpaste.

Robin also introduced me to the London exhibition scene. At the time, it offered a good opportunity to get my work seen by the general public and maybe to sell the odd painting. The exhibition that played the most significant part during this period was the Open Air Show on the Embankment. For what now must be nearly thirty years, the Greater London Council has put on a free-for-all art

exhibition in the Victoria Embankment Gardens during the first two weeks in May. The original idea has spread —nowadays, on a Sunday in London, almost every length of railings is covered in paintings. For the Embankment exhibition, a long length of chainlink fence was put up along the edge of the path. This was sub-divided with tapes into approximately 6ft by 6ft sections. Artists would arrive the night before and, when Big Ben struck midnight, would put a picture up and claim a 'pitch'. We could then go away and risk the painting being stolen— which, oddly enough, it never was—or else stay there until the early hours. Each pitch was provided with a tarpaulin on the back of the chainlink, so that when it came on to rain, which it always did, this could be pulled over the pictures. The Chairman of the London County Council— as it was then—used to come along on the opening morning to have a look at the exhibition, but there was no selection committee. In the eleven years I exhibited there, I only remember one picture being rejected: a badly drawn painting of a man in his bath.

There were always more artists than pitches available, and, at the end of each day, we balloted for the next day. We never knew where our pitch was going to be and would always be next to somebody new. The grand thing about this exhibition, quite apart from the fact that there was no selection committee or hanging fee, was the wonderful freedom. You could put one small picture in the middle of your pitch or cover the entire 6 sq ft with miniatures. You could come and go as you pleased, and sell for whatever prices you thought reasonable. And the public loved it. Enormous crowds of people would come through in the lunchhour every day, particularly in warm sunny weather. The exhibition was just outside the Embankment entrance of the Savoy Hotel, so we had many VIPs walking through.

The camaraderie between us all on the Embankment was a side of artistic life which I have only experienced on these occasions. Generally, the traditional ones among us, those of us who paint something recognisable, are chasms apart from the Bohemian types who fire paint out of a gun and think the world owes them a living. But we all mixed in on the Embankment. I used to sit on the seat opposite my pitch in all weathers and if I had not sold much and was thirsty or hungry, I asked whoever was next to me to look after my pitch while I went into Bert's café under Charing Cross Bridge. Several times whilst I was revitalising, the long-haired beatnik who had been looking after my pitch would come running into the café to tell me that he had a customer for me. In the normal course of events, we wouldn't have spoken to each other. I would do the same for him, of course, and it taught me a lot about people.

There was one married couple there who were brown, from head to foot. She smoked a pipe. He had a brown beard and wore a brown hat and a brown overcoat and brown socks and very dirty brown sandals. There was an air of sad foreboding about him. He never said a word to anybody, unless someone really made the effort and started chatting to them. It turned out that he had led a pitifully brown life in a slave camp somewhere in Europe. This tragic environment had coloured his whole outlook on life, as well as his paintings: they were brown too. If only he could have let a little sunshine into his life he would have been a good artist. He had great talent and he could draw.

Unfortunately, the Open Air Show acquired a bad reputation, quite unfairly. This was because the sensational press came down every year and wrote a lot of rubbish about 'Bohemia among the Tulips'. This, and other sickening clichés about starving artists, used to appear in the

evening papers every year. One day I was sitting opposite my pitch in the sunshine, wearing slacks and open shirt, with a Stowe silk square around my neck. No wonder the Old Stoic walking through the exhibition in his lunch hour from his City office, with his bowler, brolly and pin-striped suit, looked aghast to see another Old Stoic apparently on his beam-ends. I have never seen such a pompous expression on anyone's face: he obviously thought I was letting down the old school. However, his attitude changed after he had heard of my sales over the previous days. 'Christ, you lucky bastard. I can't earn that in three months in my stuffy office!' I think he went away seriously considering taking up painting for a living.

The most I got for a picture up to that time was 150 guineas for one of Shepherd Street, Mayfair, which I sold from the Embankment exhibition. We always charged in guineas. American customers positively enjoyed being asked to pay in such a strange currency, and also it brought us more money!

The Open Air Show seemed to have different fashions in so-called art every year. One year it would be flower pictures, and the next landscapes. One chap invented a new way of portraying flowers, building them up with a sort of plaster base and then painting them. These caught on to such an extent that he was busy wrapping them up like a barrow-boy in Oxford Street. He used to dash home and paint a whole lot more for the next day. And good luck to him. Two elderly ladies came every year and used to paint hundreds of pictures specifically for the Exhibition. They came up at the beginning of May and established themselves in a comfortable hotel. Their 6ft pitch was completely covered in little flower pictures, never much more than 6in by 4in including the heavily gilded frame. For 5s you got two flowers in a pot, and for 2s 6d you got one. They sold like hot cakes, enabling them to live com-

fortably in Hove while they painted another lot in the remaining eleven months of the year.

There were also a few serious professional artists who, like myself, recognised the Embankment as a marvellous showcase. Indeed, people used to come down from the opening of the Royal Academy Summer Exhibition and say what a breath of fresh air it was to see some real art — at least, they said, it was 'genuine'. My own pitch was certainly full of variety. On most occasions I showed either an aeronautical subject or a steam engine. For many days I exhibited the painting I did in Crewe railway works and this created an enormous amount of comment from passers-by.

It was at my first showing in the Embankment Gardens that I learned the hard and bitter lesson of being beaten down. For some reason, going back into history, artists are always assumed to be confidence tricksters, charging far too much for their work. I had not sold anything and it was well into the second week. A smartly dressed man gradually wore me down by stages until he got a £25 beech-tree painting for twelve guineas. I carried the painting to his car and the blighter drove off in a Rolls Royce. I decided there and then, 'My God, I'm never going to be beaten down again.' Several years later I was charging in the region of £35–£40 per picture. A man offered me £20 and to his astonishment I at once pointed out that £35 was the price and that was what I expected to be paid. He apologised profusely and explained that he was in the Covent Garden market trade and that it was his habit to barter for everything. We parted the best of friends by meeting exactly half way: I beat him up from £20 and he beat me down from £35. He had the painting for £27 10s. I took off the frame! I remember selling one picture in the pouring rain when it was almost dark. Everybody else had gone, but I had decided to hang on. A persistent member

of the public decided to walk down the line lifting up all the tarpaulins, determined not to miss anything. I had one left. I hauled it out from under the tarpaulin and, with rain pouring off his trilby, he bought it.

This was the stage in my life when I went round, as every aspiring artist should, to all the advertising agencies. Robin had instilled into me that I should always have pride in my work and show it framed. I look back with amusement now to those days when I was a veritable removal man. The lifts in the buildings never seemed to work. I used to struggle up at least half a dozen flights of stairs carrying enormous oil paintings, with the frames knocking each stair right up to the top. Then would come the classic answer, 'Don't call us, we'll call you.' I would then stagger all the way down the stairs again—and they never called. But it was good training, and it kept my weight down. More importantly, my work was being seen.

And I began to see for myself some of the less pleasant aspects of London's exhibition scene. Robin was highly successful—and so he had enemies. When he submitted pictures for an exhibition I saw some of them chalked with a rejection cross before they were even seen by the selection committee. This also happened to my pictures, but I was still training. Perhaps the people who did this sort of thing were afraid that our exhibits would lessen their chance of a sale. But in 1954 I sent in a painting to the Royal Academy for the Summer Exhibition and it was accepted. The picture, of a little antique shop, was number 648 in the catalogue. It was hung above an electric plug socket in gallery heaven-knows-what number, at floor level. Everybody kicked it as they went in through the door. You had to get on your hands and knees to look at it. But it still sold!

My mother and father were, not unnaturally, immensely proud that I had a picture hanging. My father put his best

suit on, always an extreme act for him, and we went to the private view. My mother entered Burlington House first, and the commissionaire's arm then came down across my father, preventing him from entering. 'Haven't you read your ticket?' he said. 'Admit two, including exhibitor.' I went down to the office for another ticket and this was refused. So I had to take my mother round the exhibition, put her into a crawling position to see my picture, and then leave her out in the car park, while my father had the same treatment. Yet so many of the people drinking champagne at the private view had absolutely nothing to do with painting. To them it was just a social event at the beginning of the London Season. This kind of sham façade gives the exhibiting of art a bad name.

There is a tremendous hunger among the general public to find out about art. So, quite innocently, they go to the Royal Academy or to the Tate Gallery because they assume that the work in there 'must be good'. In the Tate Gallery, mixed up with the beautiful Rodin statues, they see bits of bent wire and tin cans dangling all over the place, and come out totally bewildered. If it is in the Tate Gallery it must be good. In fact, it is only in the Tate because the trustees and the Arts Council buy it with taxpayers' money and put it in there, and the public have precious little say in the matter.

4 ON MY OWN

I begin my career, as the 'London Airport Artist'—a Comet test flight—'get that bloody artist out of the way'—big, bad business —painting in the railway works, with a Duchess—'Service by Night', and problems with the milkyard—first exhibition— Avril, and marriage—puppies in the paintshop—hitchhike to Greenland and the States—from the Coconut Grove to the YMCA and home in a hurry

It was during 1953 that Robin announced that he had finished with me, 'I can't really teach you any more— you're on your own.'

Never did good luck favour anybody's life more than mine. My father merely said, 'You can spend the first twelve months living at home so you don't have to worry about the bread and butter.' If I had had to earn my living straight away, I might well have ended up in an advertising agency designing posters—nothing wrong with that but, looking back, it would not have given me the chances that eventually came.

It seemed a natural progression from the days as a prep-school boy fascinated by Dorniers and Heinkels to special-ise in aviation. So London Airport seemed a natural place to start my artistic career. My father owned a hotel in Camberley at this time and I had painted some small pictures of Hunters, Javelins and Canberras to hang in one of the lounges during the Farnborough Air Show; all the hotels for miles, including ours, would then be bursting at the seams with aircraft people. I did not sell anything: I had only just finished training and they showed great immaturity. But that humble start inspired me to push ahead in this new and rather exciting field. There was then only

a handful of acknowledged experts who painted pictures of aircraft. And there was plenty of scope in the post-war years for new people to try and bring a bit of art and aesthetic relief into the aircraft industry's factories and boardrooms.

Heathrow was a very different place from the concrete jungle it is now, and 1953 was a gloriously hot summer. I had a permit which enabled me to drive almost everywhere I liked. I had complete freedom to go to nearly every hangar on the airport and there I used to sit, day in and day out, amid the noise and dirt, painting aircraft and painting more aircraft. My old yellow and green pick-up truck was a familiar sight outside the Comet hangar, and in the maintenance area of all the major airlines. I was accepted as one of the airport fittings, and even became known as the 'London Airport artist'. Coaches taking sightseers on conducted tours used to draw up right behind my easel and over the microphone inside I would hear a highly inaccurate and sometimes rather coloured description of myself and what I was doing. I even appeared on television as a result of painting the scene before the departure of the London—New Zealand air race. The KLM DC6A was lined up with the other entrants in the transport section, and I chose to paint it because of the handicap system; it was a certain winner. I took the gamble that, if it won, KLM would buy the painting. It did and they did—for £25.

As far as the physical problems of painting at the airport were concerned, the wind was always the worst hazard. Airports are the windiest places on earth. I used to put three bricks and a car jack on the platform of my folding easel and still the thing would shake like a jelly. Brushes would blow away. And then there were slipstreams. Just when I was engaged on a particularly detailed part of the picture—the wheels or markings of the

aircraft, for instance, when absolute rigidity of canvas, hand and palette is essential — somebody would start up an engine. The painting would be either sucked forward or blown backwards. I had to hang on to it for dear life to stop the whole thing taking off. Sometimes I would get nicely engrossed in a painting when a voice from the cockpit would say, 'Sorry, mate, got to tow her away now.' And so I would follow my 'sitter' over acres of concrete to the other side of the airport. Usually she was lost amid the welter of trolleys, baggage trucks and other paraphernalia of a busy terminal area. The light was always different but I usually managed to carry on. Such persistence drew the inevitable remark, 'Why the 'ell don't you take a bloody photograph and 'ave done with it?' But they used to tow airliners out of the hangars especially for me. The airport people bent over backwards to help.

This was the era of Stratocruisers, Constellations, Viscounts and the early Comets. All the time I was giving away pictures to the aviation companies, my best chance of getting noticed by them. A number of these give-away pictures are still hanging in their boardrooms. In the end, some of them felt obliged to commission the odd painting and recognition of my work gradually percolated into the people who had influence. At that time there was a company giving joyrides in marvellous old Rapide biplanes from the middle of the airport. The public enclosure consisted of a couple of wooden huts surrounded by a chestnut-paling fence (with a bucket as the men's loo). In the cafeteria there I had permission to hang my pictures as a sort of permanent exhibition. If I left them there too long, they turned dirty yellow, covered in a thin layer of fish and chip grease; but it was still well worth it.

The Chairman of BOAC, Sir Miles Thomas, came in one day, noticed my pictures and commented that it was obvious I had never flown, from the way I painted clouds

(I had made my first-ever flight a few years before, and hadn't really felt like studying clouds for a painting when I was being airsick). Sir Miles offered me the chance of going up on a test flight in one of the early Comet 1s. So I began to get a taste for flying and learned the thrill of aerial landscapes. Unless one has flown in a sunset at 30,000ft, one cannot begin to appreciate the beauty of it all. It opened up a whole new horizon.

One of my earliest commissions was to paint a pilot's eye view of a night-time approach to London Airport. The owner of a Dove aircraft agreed to flip me around the airport after dark and do a circuit over the approach lights. Meanwhile, on my headphones I heard a steady stream of fruity comments from impatient pilots of foreign airliners, intent on getting down with their load of passengers after a long flight: 'Get that bloody artist out of the way — we want to come in.'

I had an interesting insight about this time into the workings of 'big business'. I was exhibiting a picture of a Solent flying boat over Tower Bridge, and it caught the eye of the chairman of one of the biggest aviation companies. He asked if I would be good enough to paint out the flying boat and replace it with a jet bomber, one of their products. I naturally declined, but undertook to paint a similar picture using their aircraft. This was duly delivered and hung on the boardroom wall. There was then a changeover of chairman and the new man saw the original with the flying boat, in another exhibition. He quite firmly decided that this must be a copy of the company's picture. A meeting was called in the palatial boardroom. Three of us sat at the enormous polished table, around which, in saner moments, vital company business would have been transacted. At one end was the chairman himself. Across, just at shouting distance, was myself. The man in the middle, who did not seem to have anything to do

43

with anything particular, was apparently the self-styled arbitrator. Having wasted at least half an hour of the company's time, when they surely could have had something better to do, the verdict was that I should destroy the original painting of the Solent flying boat over Tower Bridge. On reflection, I cannot imagine a more pompous decision or more stupid situation, but being green in those days I thought I had to do what I was told. However, I am grateful for the experience : at least it taught me how small 'big' men can be.

I learnt another equally painful lesson after being approached by a big firm of fine-art publishers, who have a splendid and long-established London gallery. They asked if they could make a fine-art print of my painting of Shepherd Street, Mayfair. The managing director took me to lunch, complete with brandy and cigar—'Have the whole box, my dear fellow'—and I listened at length to how I was going to be made famous from Honolulu to Singapore. The print would be a magnificent seller and make me famous. I allowed them to publish the print; it is, I believe, still available. And to this day I have yet to be paid one penny in either copyright fee or royalty. I discovered later that this has been, and still is, their policy with young and green artists—to make a quick killing and then drop the person concerned.

Railways started to join the planes in my life at about this time. Before the war, my father had the most beautiful O-gauge model layout, and from this undoubtedly springs my passion for steam railways. And now that I was a professional artist on my own, I began to realise that the steam railway scene might offer the most magnificent material for paintings. Not then having the commitments and responsibilities that one acquires later in life, and being able to paint much more for myself, I seized every opportunity to put into practice the rigid training that

Robin had given me. The first railway picture I ever painted was in the great engineering works at Crewe, where with the railway's permission I worked for nearly a fortnight. They employed, I was told, 6,000 men in the works and I am convinced that every one of them stopped work to look at what I was doing. I was finally such a distraction that they had to put screens around me to enable a return to normal working. It was a marvellous experience and I met some super railway people. Coincidentally, the locomotive that I painted in the erecting shops was a BR Standard 9F which had never been 'out on the road'; little did I know that twelve short years later I would actually own one of her sister engines, which at that time had not even been built. It was undoubtedly that early training on Westminster Bridge and other places that enabled me to paint in such a setting: it takes some nerve to carry on undisturbed whilst 100 tons of Duchess Pacific locomotive is picked up and dangled over your head on a giant overhead travelling crane.

In similar conditions shortly afterwards I set up my easel in the paint shops at Swindon. Again, it was the same atmosphere—friendly people and co-operation all round. They actually moved locomotives especially for me—things happened like that in those days. One dear old man used to bring strawberries in from his garden every morning and put them on my easel as he walked past to his workbench.

They turned one of my pictures, 'Service By Night', into a poster. I wanted to paint the night scene at a London terminus and this entailed sketching after dark on location. I had to be escorted out off the end of the platforms at King's Cross. It was lethal around there to someone standing with his back to the tunnel-mouth and carried away by his sketching, as I usually was, because it was easy enough to step over a rail and then suddenly realise too late that

you were standing in between the tracks. Back in the studio I painted the picture, showing the coloured lighting system at King's Cross, with the trains coming in and out. Obviously, not knowing the first thing about signalling, the painting was full of faults. For a poster it had to be completely accurate in every single detail, or from the moment the first copy was pasted up, the poor railways would be plagued with telephone calls from railway enthusiasts. 'You have a passenger train coming out of there —you can't, it's the milkyard.' Out that came. I had to change just about every signal until, finally, at the fifth or sixth attempt, the painting was passed as accurate in every detail. It then went to print and I don't know how many hundreds of thousands were run off when another mistake was noticed. Some poor little bod at Waterlows, the printers, had to change every single copy by hand.

I remember my fantastic feeling of pride when I stood on railway platforms throughout Britain and looked up at *my* poster. No doubt I was the only one who took much notice of it amongst the hustle and bustle of busy passenger stations. But it gave me a tremendous feeling. That poster is now, by the way, quite a collector's item.

Those early railway paintings of Crewe and Willesden, and 'Service By Night', which were such tremendously good training for me, were bought by British Rail for £60 each. They have lost the original of 'Service By Night', but the other two are now in the National Collection at York Museum. And, of course, they are all a piece of history.

I now wanted to try to paint the hurly-burly of a busy car-production line, and obtained permission to paint the Morris production line at Cowley. The editor of the Nuffield organisation's company magazine, *Teamwork*, wrote: 'A spot at the end of number three Assembly Line, Cars' Branch, was the focal point of much attention last month. There, impervious to the hubbub and the curious

stares of those who come and go, a young London artist has been setting on canvas his impression of the Morris Oxford coming off the line. When a *Teamwork* reporter arrived on the scene, a small crowd had collected around their unusual visitor, who was standing heronlike on one leg wrapped in contemplation of the beauty of factory life! . . . A lively quality pervades his present canvas and his accuracy is vouched for by the comments of the bystanders. As one remarked, "Cor, 'e's got it off a treat." We were a trifle disappointed to find that he belies the usual conception of an artist—no beard or floppy hat, no bowtie, or even sandals! The only unusual thing that we could discover was that apparently he lives on tea and boiled sweets. Certainly, none can remember him stopping for a regular meal . . .'

There used to be a little gallery in Grosvenor Street. I hired it for my very first one-man exhibition and Sir Miles Thomas accepted my invitation to open it for me. This generated press interest and although this was long before I started painting elephants, the exhibition did me good. I showed a collection of aviation pictures, English landscapes and railway pictures, and even my little 'Esher nude' (it still didn't sell!). And Pathé Pictorial came to the gallery and made a super little film which was shown in cinemas all over Britain: they filmed Viscounts flying over Manhattan, a Britannia over Kilimanjaro, and a very evocative picture of a Lancaster bomber sitting rather forlornly on the tarmac at Blackbushe Airport. Going close in to the painting with the camera, they would switch quickly from one part of the painting to the other, and put the appropriate sound track behind. This had an amazing effect in bringing the painting to life. Dear old Q for Queenie, the ex-617 Squadron Lancaster, which I called 'A Forgotten Friend', almost seemed to move off as you heard the sound of the Merlins starting up.

Life at home, now in Camberley, was difficult. On leav-

ing the army, my father had gone into catering, starting with a restaurant in Worthing; but serving soup to old ladies was not enough for him and he bought the Frimley Hall Hotel in Camberley, which became so successful that it almost killed him after eight years. Camberley, though, was the most retired of all retired places, with the possible exception of Worthing. If you did not play bridge or golf, or have an army career—preferably in the Indian Army —you were a sort of social outcast. The hotel was full of retired old admirals and colonels who objected to the gentlest change that my father might make to awaken the place out of its slumbers. Blackberry and apple had been on the lunchtime menu every Wednesday for the last fourteen years and rice pudding on Tuesdays: he swapped them round—and all hell was let loose. My mother sensibly decided to have little to do with the hotel and ran a riding-school at the end of the drive. That also became so successful that it nearly killed her, too.

My brother and I were asked every year to a boring dance in Camberley, of which the sole purpose seemed to be to get the daughter of the particular hostess married off. So hordes of Sandhurst cadets used to be invited up, all with their pudding-basin haircuts: we behaved incredibly badly, and I must have stood out like a sore thumb among this collection of future army officers. But, this was where I first met Avril, standing rather forlornly, overdressed, by the fireplace. Her life seemed a bit sheltered—she had not even heard of Glenn Miller! We hit it off. The courting, slow but sure over several years, was kept going not only by my liking for her but by my collecting empty jam-jars. My brother had a mink farm next to the hotel and, for a reason I never quite understood, seemed to require an inexhaustible supply of jam-jars. This gave me an excuse for perpetually going round to Avril's home.

Soon after we were married in 1957 we went down to

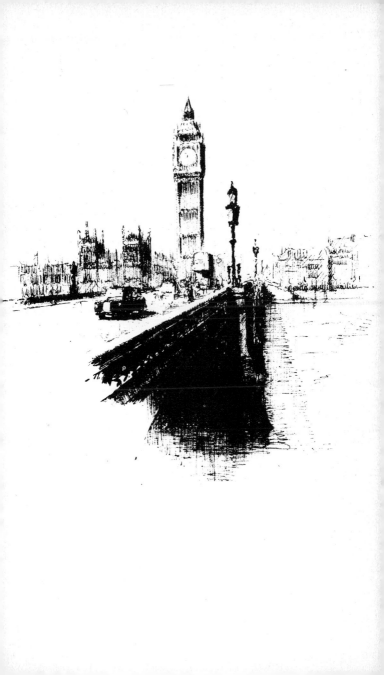

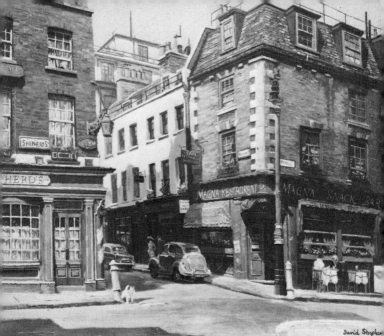

Above: 'Shepherd Street, Mayfair', 1955

Left: Exhibiting on the Victoria Embankment, London May 1956

Above right: Painting the London–New Zealand air race entries at Heathrow

Right: Painting in the erecting shops at Crewe, 1955

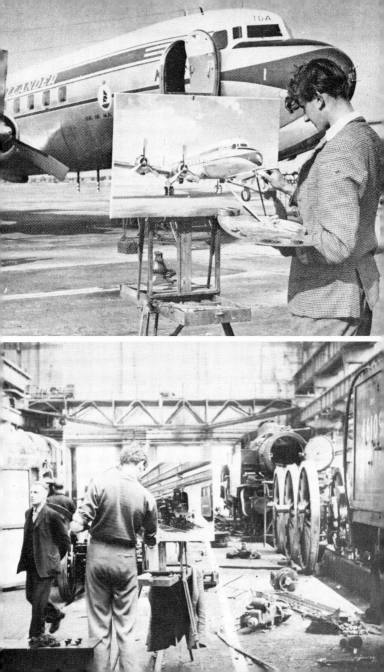

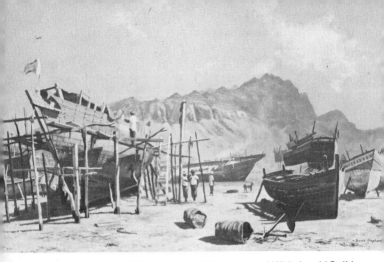

Above: 'Slave Island' (*by courtesy of Solomon and Whitehead (Guild Prints) Ltd*)

The Market Square - Shibam

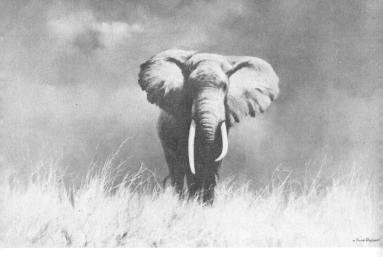

Above: 'Wise Old Elephant' (*by courtesy of Solomon and Whitehead* (*Guild Prints*) *Ltd*)

Below: Winkworth Farm (*Richard Rhodes*)

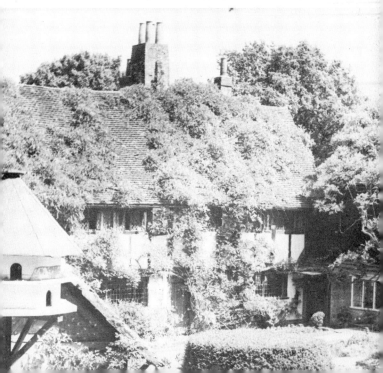

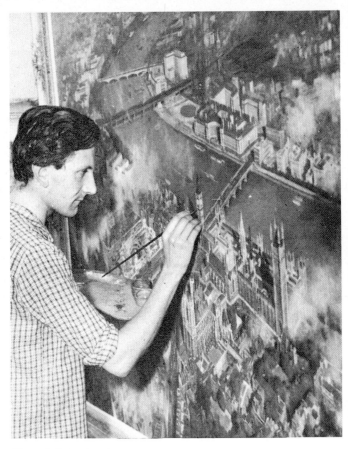

Above: Painting London

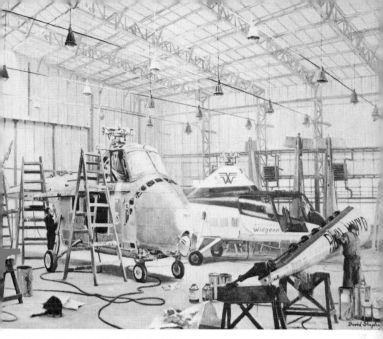

Above: Westland Aircraft Paint Shop

Nine Elms - the end of the line for a Brighton tank

Right: Painting in York Roundhouse, 1955

Below: The Green Knight and *Black Prince* at Eastleigh (*photo, Dick Weishman*)

Yeovil together while I fulfilled a commission from West-land Aircraft to paint in their factory. The nice thing about Westlands was that they managed to retain some of the family atmosphere of a small company. Off I would trundle to the works every day. My wife, in the meantime, had gone chasing off to buy a golden retriever puppy. We both considered this to be the most essential item of furniture in our first little house that my father and mother had given us, in Frensham. I was busy painting Whirlwind helicopters in the paintshop when Avril wandered straight into the factory through the security gates—apparently with permission from the managing director—carrying two little golden bundles in her arms. They waddled around the paintshop, puddling all over the place, and we bought both of them.

Avril was nineteen when we first met and was working in the local bank. I used to see her trundling up the road on a rather aged bicycle, dressed in a blue mackintosh and a blue school beret. However, she had later got a marvellous job with Capital Airlines of Washington, at Hurn Airport near Bournemouth. Capital Airlines had purchased seventy-five Viscounts from Britain; it must have been the biggest export order of the year. Avril became private secretary to the airline's personal representative who was based in England to see that the Viscounts were completed and delivered on time. She had the offer of a free trip to America in one of the Viscounts, but for some reason was not allowed to go—so I went instead. I saw this as a marvellous opportunity to get in with the big American aircraft companies, where there might be some tremendous business. An English MP and a US Air Force general, whom I knew, led me to believe that whichever door I knocked on, Boeing, Douglas or Lockheed, I would be welcomed with open arms and dozens of commissions. I set off in rather the same frame of mind as when I first visited the National Parks of Kenya.

It was a fascinating trip out. Each Viscount was flown out empty and the seating was fitted in the States. The ferry pilots used to go round the junk shops in Bournemouth and the surrounding areas buying up huge Victorian dressers and street lamps to stuff into the aircraft. So they were fairly heavily loaded. We flew first to Iceland, and then on to Greenland, where I first discovered, to my intense disgust, that the Eskimos walked around in US Air Force jeans. Finally, we flew on via Gander to New York.

I was now on my own financially. Still full of confidence I changed planes and crossed the States to Seattle, where, I assumed, I would have my first welcome. I arrived in the early hours of the morning and sat until 9 o'clock at Tacoma Airport. I then rang Boeing and said, 'David Shepherd here. I have come to paint your factory.'

'Who?'

'David Shepherd. I have come to paint your factory.'

Long silence. I must have sounded completely mad. It was obvious that my two friends in England had done nothing to prepare my trip. And to Boeings, at 9 o'clock in the morning, it must have sounded unintelligible: why should a decorator have come all the way from England when the factory didn't need painting anyway?

'Never mind. Sit tight. Obviously something has gone wrong, but we'll call you.' Sure enough, some twenty minutes later a message came through over the tannoy asking me to go to the airport entrance. There was a private car, laid on by Boeings, and in that short interval they had also booked me a room in a hotel. Later I was taken to the factory and given a conducted tour. At that time, they were producing the B52 Stratofortress nuclear bomber. And they still did not know who the hell I really was! They were very trusting. I suppose the sketches I had brought out convinced them I was not a potential enemy.

It turned out that even though they wished to commission a painting, they were not allowed to by the Pentagon because of the military aspect of their work.

So on I flew down to Los Angeles, by now worried about my finances. Aircraft have a nasty habit of arriving at airports at ungodly hours like 2.30 am, and mine did just that. By now I was so weary that I just piled myself into a cab and said, 'Take me to the nearest hotel.' This turned out to be the world-famous Ambassador Hotel and Coconut Grove. At about 4 am I staggered out of the cab in fear and trembling at my surroundings, paid off the driver with what seemed to be most of the money I had left for the whole trip, and was shown up to my palatial suite—no choice—by a rather disbelieving night porter. 'Is that *really* all the baggage you have, sir?' The rest of that night, what was left of it, took nearly all my remaining money. The next morning I came down for a round of toast in the Coconut Grove and brushed shoulders with Bing Crosby and people of that kind who frequent those places. I fled!

Safe, temporarily, in a much cheaper hotel down the road, I contacted the Douglas aircraft company in Santa Monica. The outcome was the same: they liked my work but could not commission me because occasionally a DC7 went through their production line with a bit of military equipment in it. I soon realised that American tape is an even stronger red than the British variety. However, they took pity on me and passed me down to Lockheeds, where events were once more repeated.

By this time I was a bit desperate. I left the West Coast and flew back East again, spending the last couple of nights in the YMCA in New York, queueing for my room with a lot of art students and merchant seamen. I cancelled my passage booked on the *Queen Mary*, and caught the first available, cheaper, boat.

5 ADEN, AND MY FIRST ELEPHANT

An invitation from BFAP—into remote Arabia, with a canvas, on the 'bread run'—'Slave Island', and a cocktail party changes my life—convoy to Dhala—love affair with the Beverly—up to Mukalla and into the Hadramaut—to Kenya again, and 'Do you paint elephants?'

A letter arrived in 1960 which changed my life. The envelope bore the initials BFAP. I hadn't a clue what they meant, but it looked important. Inside was an invitation from the Commander-in-Chief, British Forces, Arabian Peninsula, inviting me to come out as a guest of the Royal Air Force and paint for the services in Aden.

Avril and I were in our first home in Frensham and starting a family. I was making a reasonable living from painting and had already a number of pictures for the services. I had written an article in *Shell Aviation News* describing my life as an aviation artist and this was illustrated with some of my aviation pictures, such as those painted for Westland Aircraft. The magazine had apparently been seen by the C-in-C in Aden.

In his letter he explained that he could not actually get me on a Transport Command plane from England to Aden. But, once there and in his command, he could, he assured me, give me free travel on all service aircraft and all vehicles, from Land Rovers to army scout cars. And Kenya was included in his command.

Pulling strings relentlessly, I enlisted the help of the Chief of the Air Staff, Sir Dermot Boyle, who obtained a free trip for me by Transport Command. I had to be classed as 'press' because there is no category in the War

Office files for artists. I was to fly down the 'bus route', as the RAF called it, the main Transport Command artery right through to Australia via El Adem in Libya, Aden, and Gan Island in the Maldive Islands, south of Sri Lanka.

So, not knowing quite what to expect, Avril drove me down late one January evening to a place called Cliff Pypard, in Wiltshire. This had apparently been some sort of reception place in World War II and was now a run-down collection of damp and rapidly disintegrating Nissen huts. We spent that night huddled together in a bed in one of them. It must have been just like this in the war—a bloke in hobnail boots even came in during the middle of the night to stoke up the stove.

At an unearthly hour the following morning I clambered sleepily from the cold drizzle of Wiltshire into 'Sagittarius', a Comet 2 of 216 Squadron, Royal Air Force, at nearby Lyneham. This was the first of many trips I was to do with that great squadron. Every single time I flew with them over the ensuing years something went wrong —in fact, my name seemed to act as a jinx to the squadron. On this first flight, we were stuck in El Adem, near Tobruk, for no less than five days with the Comet unserviceable. And El Adem is not the most glamorous place at which to be stranded. The only thing to do in the officers' mess there seemed to be to get tight and then see how many empty beer cans could be balanced on the blades of the fans as they went round. It surprised me that there was not a large number of one-armed officers in the Royal Air Force! Those were hysterical, mad days and they were happy ones. However, it was a bit frustrating as I am not cut out to sit around doing nothing for more than five minutes. Finally we were on our way and after some dramatic incidents, with the undercarriage refusing to go down, or up—I can't remember which—we arrived in Aden.

Almost before the whine of the jets had died down, the VIP treatment began. 'Mr Shepherd off first, please.' There was Smithey to meet me—as the Chief Information Officer for British Forces, Arabian Peninsula, it had been his job over the past ten months to arrange all the details of my trip. And he was no doubt relieved to see me safely arrived at last. There was a car waiting for me on the tarmac and it had a flag on the bonnet—but the flag was wrapped up in a little leather thing because the C-in-C himself was not in the car with me. But I still felt frightfully important. I was whisked through the dark streets of Aden with the ADC up to Air House, Steamer Point. There on the balcony to meet me was the C-in-C, who made me feel thoroughly welcome but packed me off to bed as it was by now 3.45 am. I was awoken by a super chap in a white coat: 'What would you like, sir, anything you fancy?' On the terrace overlooking the incredibly blue sea and the harbour, I had my grapefruit and boiled egg and couldn't really believe it was all happening.

The C-in-C's car took me for a brief look at the town. It was an artist's paradise—with the narrow alleyways, smells, goats, camels and all the rest of it. We even saw a camel push its way into one of the poky little bakers' shops to grab a loaf. The shopkeeper chased the thief out into the street, picked the loaf up from the road and replaced it on the counter. There was filth and refuse everywhere, but it all seemed part of the atmosphere. The goats eat most of the waste paper—it is all they get to eat—and they function very well as the town's sole refuse disposal system.

Aden in those days was a free port and one of the cheapest places anywhere to shop, particularly for cameras and watches. Ships called here to bunker—I was told that one liner or freighter every forty minutes was the average rate throughout the year. And the Arab shop-

keepers in their little holes in the wall used to do a phenomenal turnover. The passengers, on the way to or from Australia, seemed to forget that they might have to pay duty when they reached home. They used to stagger back up the gangways of their liners loaded with refrigerators, cameras, watches, tape-recorders, and all the rest of the things that they did not really want but must buy because they were so cheap.

The following morning at 8 am a car took me out to Khormaksar to meet the Royal Air Force. Khormaksar in the early 1960s was probably the busiest RAF base overseas. Indeed, the station commander was virtually in charge of his own air force. There were eight different squadrons and units there and probably a greater variety of service aircraft than one would see anywhere else. There were Hunters and Venoms of the fighter squadrons; Shackletons of Coastal Command; Comets, Britannias, Hastings, Beverlys, Twin Pioneers and Valettas of Transport Command, and Meteors of Photo Reconnaissance. There was also a helicopter unit, a VIP Pembroke and the gleaming white Canberra jet bomber used by the ADC.

Full of confidence, I took my sketches around to all the station and squadron commanders. But, unexpectedly and somewhat shatteringly, the reaction in each case was, 'Oh Christ, not another bloody artist!' It turned out that they had only just managed to rid themselves of a certain titled lady painter who employed the rather dubious gimmick of painting aircraft pictures on bits of aeroplane. Aluminium sheeting cannot really be used for this purpose because all the oil paint runs down to the bottom in a conglomerated mess. And the result in Aden was even worse, aggravated by the heat. Apart from this, the woman had apparently made a nuisance of herself, taking her shoes off at cocktail parties, walking around in bare feet and going all eccentric. This had been enough to frighten

off the RAF for all time from anybody artistically inclined. Not only was this terribly disappointing for me; it was embarrassing for the Commander-in-Chief. That evening we all sat around the table in our white dinner jackets — another 'boardroom' tribunal, but his time a much more friendly one — while the fate of Shepherd was debated over the cigars and brandy. The verdict was that Shepherd should be shipped home to Lyneham on the first available Transport Command Comet. No hard feelings — he had had a good time for a few days and it was an interesting experience at no cost to anyone. Fair enough.

But it turned out that there was no RAF Comet coming through for about a week and I was not going to sit on my bottom all that time doing nothing. So I went down to Slave Island with one canvas I had with me of decent size — 36in by 24in. And I painted the picture that changed my whole life.

None of the trippers from the P & O liners, in their feverish rush to spend all their money on duty-free goods, ever took the trouble really to explore Aden and go behind the scenes. They certainly never saw Slave Island. Here, in the 1960s, the Arab fishing dhows were still being built precisely as in the days of the Bible — with the one exception that steel nails had replaced wooden pegs. And they were built entirely by eye and by hand. And when they considered the job was finished, they knocked away the rough wooden scaffolding — made out of bits of timber found lying around — and the tide floated the boat out to sea. The bigger dhows are now unromantically powered by diesel engines, but many of these magnificent oceangoing vessels still ply the seas between Arabia and Africa entirely un-aided except by the wind, and navigating by the stars, from the Gulf down to the coast of Kenya. What a subject they made! I put my easel up and painted for five days, depicting the scene exactly as it was in front of me. Arabs

stood around me all day, watching fascinated, as they had never seen anything like it before.

On seeing the painting, the AOC with whom I was staying in Aden said, 'This is a lot better than your sketches. We'd better put it up on the wall and have a cocktail party.' I obtained well over thirty commissions that night. Everybody wanted pictures—Shell, BP, Aden Airways, BOAC, most of the commercial and shipping companies, and just about everybody else. It was a chain of rather nice circumstances. Aden was full of subjects to paint; there was nobody to paint them and lots of people to buy them if one did. The RAF decided that they would not now ship me back to England. Instead they showed me the whole of the command—not only right up country into the edge of the empty quarter of Arabia but, much more significantly, Kenya. So I shall always be grateful to them.

An intensely full six weeks began. It seemed that I never went to bed. The social life was hectic but enjoyable and usually went on until the early hours. Then I would get up before dawn to go on the 'bread run'. RAF Transport Command's basic job was to keep the army supplied from Aden. The troops were up in the Radfan mountains in the interior of the West Aden protectorate on the borders of the Yemen. As always, the poor old British were trying to keep the peace between warring factions. Either the tribes up there were fighting each other or they were all fighting the British. The army units were camped in remote little outposts in the rocky, sun-scorched brown-yellow landscape. There was hardly a green thing to be seen. It was like the moon. Up on the escarpment about 3in of rain fell every five years, and most of that all at once. The only access to the interior from Aden was by way of a few camel tracks, and so the army, living under canvas up on the escarpment, was kept supplied by the RAF. The 'bread run' flew up daily and landed on little desert air-

strips alongside the biblical Arab villages. I went along too, with my easel and canvas. And, if time allowed, I would seize the valuable few minutes and paint where no artist had ever been seen before. If I have to decide which part of the world has made the greatest and most lasting impression on me, for its sheer beauty and remoteness, it has to be the interior of Arabia. It was a wild raw life.

The RAF did a phenomenal job to keep those planes flying. Khormaksar was basically built on salt and this fact, coupled with the very considerable humidity in Aden for a large part of the year, resulted in the most appalling corrosion problems for the aircraft standing in the open. But with strict safety inspections, the operations seemed to go smoothly. Food and some other necessities were taken up in the lighter transport aircraft, such as Valettas or Twin Pioneers. But the heavy stuff was transported by the unbelievable, lumbering great workhorse, the Beverly. And my love affair with this aircraft began.

Hitherto, my only experience of seeing the Beverly had been at the Farnborough Air Show, where it seemed to be an almost permanent fixture surrounded by geraniums, waiting for buyers. But in Aden it was doing the job that it was really designed for, in conditions no aircraft should ever have flown in. To fly in the Beverly for the first time, particularly in that environment, was an unforgettable experience. It was an amazing aeroplane. The army drove their 3-ton Bedford trucks up the ramp and these disappeared into the cavernous hold of the aircraft. They used to shut the doors, then push about fifty troops up into the tail fuselage. After half an hour's flying time or so, this enormous aircraft would put down on a completely raw, sand airstrip. By reversing the pitch of its propellers, it would almost stand on its nose and stop dead. It had to, otherwise it hit the mountain at the end of the runway. The whole aeroplane, except for the tip of the tail, would dis-

appear in a sandstorm of its own creation. This would then take half an hour to subside, after which the aeroplane would re-emerge, apparently none the worse for wear. This astonishing scene was a subject I recorded on canvas for three different RAF units.

To get up to the villages on the escarpment, the crews had to fly for up to two hours over country which all looked exactly the same and where a forced landing would be disastrous. The navigators had to be on their toes, for if they strayed over the border in this featureless landscape into the Yemen, it was quite possible to be shot at by Russian-made anti-aircraft guns. And yet one of the extraordinary things about this part of the world was that, if anyone did survive a crash landing in this remote lunar landscape, the chances were that within half an hour a small Arab boy would appear herding his sheep and producing from goodness knows where a tin of grapefruit which he would then try and flog to you for an exhorbitant price! The escarpment over which the aircraft had to fly was a 3,000ft sheer wall of grim, volcanic rock.

Arab traders used to take their wares on camel carts to villages at the top. Apparently the camels knew the route so well that, before he had even left Aden, the owner would go to sleep with his feet up on the shafts and wake up three or four days later at the correct destination. The camels even used to stop at the red traffic lights in Aden. Beyond the escarpment lay the empty quarter. This is the great 'sand-sea' of Arabia, an area the size of France, where in some places rain has fallen only once in twenty-five years.

One of the most fascinating places is the mud-brick village of Beihan. We left Khormaksar at 5.30 am in an 84 Squadron Beverly, the commanding officer pointing out that the barren terrain down below must have been fertile once. 'Look, there is the Queen of Sheba's staircase.' Cut

into a barren mountain side was a huge, seemingly point-less, flight of steps—the route Solomon is said to have taken when he visited Sheba. The unexcavated founda-tions of a lost city could just be discerned below the sand. And the edge of the great sand-sea was gradually advanc-ing, burying entire mountains. To land at Beihan, the Beverly had to do a tight turn around a sugarloaf moun-tain and immediately drop down on to the dusty airstrip. We unloaded the usual 3-ton truck with supplies for the garrison and the Beverly flew off when its sandstorm had subsided enough for it to see the way. In the meantime, I was whisked off in a Land Rover by a British sergeant so that I could see the village and make the most of the few hours available.

These places can have changed little since biblical times. The mud buildings were all castellated, with sev-eral storeys. And they could have been designed just to be painted by an artist. The only touches of 'civilisation' were the small army camp outside the village and the 'great silver birds' which landed a couple of times a week.

In those days, when the British still had an influence in this part of the world, the Foreign Office stationed 'poli-tical advisers' in these remote regions. One such gentle-man, who covered the area in which Beihan was situated, happened to be in the village on the morning I arrived. We surveyed each other, hands shielding eyes from the blaz-ing sun, from opposite sides of the little sandy centre of the village. Stanley and Livingstone had nothing on this. It turned out that we had been at Stowe together. There followed the typically British greeting, 'Christ Almighty, old boy, what the hell are you doing here! Come and have a whisky.'

In the hopelessly short time before the Beverly came to take me back to Aden, I drove round desperately trying to get down on canvas some sort of a colour record. I knew I

60

was seeing something no artist had ever seen before. In three hours I managed to paint a 30in by 20in canvas. What an experience it was! I set up my easel under a date palm. The local people, who had lived there undisturbed since time began, had never seen a painting, let alone one actually being executed. My easel was soon surrounded by turbaned Arabs and veiled women. They watched everything I did—every movement. I had the British sergeant with me, but their natural good manners kept them at a distance. The sergeant knew some Arabic and told me snatches of what they were saying. First they thought I was writing a letter home. Then, when they recognised the houses I was painting on the canvas, they really got excited. They could not seem to grasp the fact of everything being in duplicate. As I was painting a particular palm tree in the near foreground, the elderly owner of the tree showed great distress because he thought that when it began to appear in the painting, I was going to take the real one away. All the villagers wanted to know to whom I was going to flog the picture when it was finished!

An old man came round with a little teacup and an Arab teapot. He offered me a cup of tea and, although the flies were competing for a drink, I knew that to refuse would offend him. So I drank his offering and another and another, beginning to wonder when I could refuse more without upsetting him, a problem solved when his supply ran out. After snatching a quick lunch with the army in their tent, I was whirled off in the Land Rover to the Beverly, and in a couple of hours was back in Aden. It all seemed like a dream, another world. I had painted in a crowd in London, but this had been something completely new. I discovered years later that the Arabs in Beihan subsequently calculated their calendars by 'so many moons since the painter came'. Their normal system was to tabulate their twelve months from some tangible happening

— such as a camel falling down a well — but my appearance on the scene was thought yet more unusual and interesting. Perhaps it is celebrated in that way to this day : I like to think so.

There was one road from Aden running right up through the escarpment to the top, to a village called Dhala. It was built, I believe, before World War II by the Royal Engineers. In a way that is peculiarly British, the road was brought up to the standard of a modern, tarmacadam highway just before the army pulled out of Aden. Presumably the Russians now have all the benefit of it. In 1960, however, I went up on what was known as 'the Dhala convoy'. The army warned me there was a certain element of risk. On the journey previous to mine, an unbelieving British major had been shot in the leg by a dissident tribesman. Apparently this officer was fresh out from a course in England and refused to believe any of the stories about these chaps who go around popping off rifles at each other, or at the British. He was soon convinced that they did and he returned to Aden on a stretcher.

The supplies were taken up in 3-tonners and the VIPs, if there were any, and the officers, were driven in Land Rovers. For escort there was a Ferret scout car. The vehicles took terrific punishment on this route and the army reckoned that they only got about twenty or thirty return trips out of a new Bedford 3-tonner. It would then be put up for auction or, if beyond repair, was left standing where it had broken down in the desert.

The only other traffic to and from Dhala might be a few Arab traders in the battered ex-army trucks which they kept going by a miracle of ingenuity : though clapped out by the army before being sold, the Arabs would probably get two or three more years' service out of these vehicles in this fearsome country. They were overloaded

beyond belief. A truck would be stacked up to the point of almost overbalancing with the top weight, then the inevitable goats and crates of chickens were put on top, and innumerable people stuffed into the cab and every nook and cranny. Off they would go, philosophically accepting the fact that they would probably break down, but would soon be rescued—if it was 'the will of Allah'.

We set off at 5.30 am to reach Dhala by nightfall, though the distance was a mere 90 miles. About 30 miles from Aden we duly came across a broken-down truck. The Arabs had offloaded half its contents along the edge of the wadi and were sitting there just waiting for something to happen. Being the sort of people we are, the whole military convoy was held up while we hitched a rope to the front of the truck and got it going. It turned out that it had broken a half-shaft while crossing one of the water courses; The Arabs usually carry spares of every sort, and remarkably, in this case, the Arab driver had actually changed the half-shaft under water. He had then struggled out under his own power, but the truck had packed up again.

A few miles further on, we came across a relatively new-looking Land Rover belonging to one of the wealthier Arab merchants. He, foolishly, had stopped for the night at too low a level. There had obviously been a flash flood down the wadi which had caught his vehicle and swung it round several times. When it rains in this part of the world, it comes down in a solid sheet for a matter of minutes, tears down the water courses and soaks straight in. A couple of hours later the ground was once again dust dry. On opening the bonnet of the vehicle, we found the mud up to the level of the top of the engine. By the time we returned from Dhala the following day, he had started the thing and gone on his way!

We gradually climbed slowly up into more and more remote country until we reached the wall of the escarp-

ment. Here, the engineers had blazed the trail up through the Khoreiba Pass, just a stony track, hugging the cliff walls and gradually struggling to the top, 3,000ft above.

At the time of my visit, tribesmen from across the border in the Yemen were causing trouble with the local population and the British by taking pot shots at all and sundry, and rolling boulders down on to vehicles climbing the pass. So one Bedford went up at a time, with a foot patrol behind and in front, a Ferret scout car as escort. When that group was at the top, the next one would be called up by radio. It would take several hours for the whole of the convoy to negotiate the pass, which was a fairly hair-raising experience in a Land Rover whose driver I was convinced was going too fast. The front wheels seemed to go far too near the edge of the precipitous drops at each corner and I had dizzy visions of the rocky valley horribly far below. At the top I was slightly disconcerted when my driver told me he had never been up before.

If a vehicle broke down on the way up and could not be immediately repaired it was shoved over the edge so as not to hold up the convoy in this potentially dangerous area. One Bedford 3-tonner, which had to be pushed over, rolled down and down into the bottom of the ravine. On the way back down the pass the following day, some troops went clambering down to retrieve something or other from the wreck and found the engine had vanished — the ingenuity and inventiveness of the local Arab tribesmen again! Most people would need a block and tackle to lift the engine out of even a small car, and here, during the few hours of darkness, the engine of a 3-tonner was removed without any mechanical aid whatever. No doubt it was repaired and working a few weeks later in an Arab trader's truck in Aden.

A small picture I painted of this historic journey was

purchased by the Royals, the regiment who took me up. The major work I was to paint from it has had a very chequered history: the Royals were not interested in buying it—they said that £90 was too much money. It was most valuable to me, however, as an example of the sort of thing that I was to do for the services on so many occasions. Later I was asked by the Arabs, who had now become the Federal Regular Army in Aden, if it would be possible to turn the Royals into Arabs; they would then buy the picture. So I cut the British trousers to shorts, changed the registration numbers on the Land Rovers, and gave the troops a darker skin and Arab head-dress. The painting was accepted with delight at the proper price, and hung for several years in the Arab officers' mess in Aden. At the time the British were pulling out of Aden, a senior British army officer telephoned me. 'We've simply got to get that painting and bring it home to England, otherwise they'll set fire to their mess and burn it. What do you think?' Not on, I told him, to take back what did not belong to us. If the Arabs wanted to burn their mess and the painting in it, that was their affair. However, I believe the painting was in fact brought back to England and is now hanging in an army museum.

I always get excited by everything and everywhere new to me, but without any doubt Mukalla and the Wadi Hadramaut in Arabia is the loveliest and most awe-inspiring part of the world I have even see. Moreover, it was the least visited and the hardest to get to. The RAF happened to be chartering a DC3 from Aden Airways and I hopped aboard. After a hot and bumpy flight for 300 miles along the sandy coast toward Muscat, we saw Mukalla below us, an incredibly blue sea and an ancient collection of gleaming white buildings around a bay. The precipitous mountain that towered up behind the town of crumbling buildings looked like a cake of strawberry ice on the bottom

layer and chocolate ice on the top. We landed about 15 miles out of Mukalla, Riyan airfield being a small tented RAF camp, and a runway formed entirely of flattened-out coral, just about the minimum length required for a DC3. As no bits of aeroplane littered the sea, it must have been safer than it looked.

Friday is the Sunday in this part of the world and the CO at Riyan airstrip told me I would have to wait until all the Mukalla Europeans—eight of them— had come up after lunch to play the RAF at cricket before I could be taken to Mukalla. It was all terribly British—I half-expected Noel Coward to arrive. By lunchtime the temperature must have been well over 100°F. I could do nothing but mope around and bite my finger nails. Eventually, amidst clouds of dust, two Land Rovers arrived with the European population and the match began.

These Europeans living and working in Mukalla—one even had his wife with him—were Foreign Office people, bank officials or military personnel. Their only contact, as far as I could see, with the outside world was by radio and a very irregular air service, operated by Aden Airways, when there were enough people, chickens, and all the rest of it, to fill a DC3. Occasionally, a truck might make the journey to Aden and back down the coast, always suffering very considerably in the process. Electricity had recently been laid on in the town and there was neon lighting down the main street—they were proud of it, but from the artistic point of view it defied comment.

Once every month or so a Brocklebank steamer dropped anchor off the bay to deliver a new Land Rover or some fresh fruit, butter and petrol.

Almost the only vehicles in the town were a few battered ex-army Bedford trucks. I only saw one private car in the town. This was a very delapidated pre-war Humber. Because of its presence, an enterprising Arab shopkeeper

had put a beautifully painted sign saying 'Rootes Group Dealer' above his little hole in the wall. I showed a photograph of this to the Rootes Group headquarters in Piccadilly, who with a singular solemnity remarked that they did not think 'this was one of our official accredited agents'.

Mukalla is a beautiful place. The old Arab buildings climb up the foot of the ice-cream mountain, all painted a dazzling white. Few had glass in the windows, just gauze and shutters to keep out the flies and sun — and nearly all the surrounds were painted a vivid blue — perhaps the last Brocklebank steamer delivered only blue paint. The mosque was the dominating feature on the curving waterfront. The faithful were no longer called to prayer by means of a megaphone — a wind-up gramophone summoned them instead. Big Arab fishing dhows were anchored in the harbour or drawn up on the beach for repair.

When walking through the quaint little streets of Mukalla I would be followed by literally dozens of dirty, attractive children, always full of smiles and a craving for cigarettes. The Arab tribesmen who came into town had a magnificent nobility about them. They were some of the most impressive people I have ever seen, with their flowing robes, long black hair and jewelled daggers in their belts.

There were certainly no European hotels in Mukalla. If you happened to be a visiting Englishman — and this in itself was a rarity — a signal had to be sent in advance to the Political Resident to inform him of your coming. You then stayed with him at 'The Official Residency of Her Britannic Majesty's Representative to the East Aden Protectorate' or something like that — the address stretched across the top of the notepaper. The place was, however, more aptly and affectionately known as 'Dysentery Hall' — I was told that if you stayed there long enough, you were guaranteed to get it. The building was a deliciously

Victorian relic from the days of our great colonial empire: a rambling, two-storeyed affair with a beautiful portico and a white wall all the way around. And there was an Elsan in the bathroom. A couple of magnificent Arabs stood on guard on either side of the main entrance and the Union Jack flew proudly from the masthead. At sunset, they used to stand smartly to attention and, while the bugle played, the Union Jack was hauled down. I count myself fortunate to have lived through an age when one could still experience such moments. They were moving in their simple sincerity, and I cried every time the little ceremony took place.

Determined not to waste a moment of my short time in Mukalla, I painted a 20in by 30in canvas right in the middle of the town square. A splendid bedouin tribesman was assigned to protect me from the seething crowds. A huge man with hair down to his shoulders, a long horse-whip and, in his belt, a lovely jewel-encrusted dagger. His method of crowd control was to crack his horsewhip at the kids as they came round the corner, whereupon they would disappear in a cloud of dust; then in a few seconds, they would filter back again, all in good humour, and they thought it a huge joke. Every tiny window around the square had several faces in it, staring at me all morning. One woman even started milking her goat almost under my easel! It was quite an experience to paint in such a setting, knowing that the inhabitants had never seen such a sight in their lives.

If one was especially lucky, I was told, one might have a chance of getting into the Hadramaut itself, and Mukalla was the only stepping-off place. The only way was by a DC3, if one happened to be going. The RAF did everything they could to arrange it all for me and the whole morning was spent sending signals from Mukalla into the Wadi. It all depended upon whether the British Political

Agent happened to be there, for he was the only person I could possibly stay with. It would be 'Dysentery Hall' all over again, only this time probably more so. There are no hotels in the Hadramaut, and no civilisation as I knew it in my comfortable life. Finally, a signal came over the air to Mukalla: 'Reference yours of 10.20 hours. Artist welcome. House available. Arab cook. American anthropologist thrown in for good measure.' Taking my life in my hands, I accepted. It was the thought of the American anthropologist which worried me. So began a mad panic to rush back to the Residency, throw everything into the Land Rover and report to Riyan by 1.30 pm.

The DC3 flew over absolutely desolate country with no signs of habitation and then we saw the Wadi. It looked like the Grand Canyon. We flew the last few miles below the top of the walls of the Wadi and dropped down on to the airstrip of Gatn, coming to a halt in clouds of dust.

The Wadi Hadramaut is unique. Stretching for over 100 miles, it is like a gigantic channel cut deep in the flat, barren landscape. It is almost consistently 4 miles wide all the way along. Towering to 1,000ft on both sides are enormous sheer walls of sandstone, with great grooves eroded in them by the rain. The floor of the Wadi is flat, bare sand, and here there are occasional cool, green oases of date palms. Little clusters of castellated mud-brick houses huddle together to form the most picturesque villages— despite being thrown together, the houses seem to have the most beautiful design and symmetry about them. In the crystal air, a feeling of total peace and stillness prevails. If I have to choose, this was for me the most beautiful part of the world I have ever seen. There are no tourists up here, no telephones, no electricity and no screeching jet aircraft or raucous motor bikes.

In the Wadi there are the three ancient and enchanting Arab cities of Shibam, Tarim and Saiwun. The Political

Agent's house, in Saiwun, was a traditional old building, all white inside and out for coolness. The bathroom was virtually an indoor swimming pool. The water came through a hole in the wall from outside and was heated by the sun. The sanitation, primitive but effective, was the good old 'long drop'. Our evening meal was of goat meat and spicy sauces—the goat must have given himself up in old age. Afterwards the anthropologist, who looked more Arab than American, and I listened to Max Bruch's Violin Concerto on a transistor gramophone. Never has classical music had such a deep meaning for me. We sat up on the flat roof of the house in the clear, cool night air in the middle of nowhere. All one could hear above the sublimely beautiful music was the tinkling of goat bells and the occasional braying of a donkey, and in the distance the calling to prayer from the tops of the mosques in the town.

On the following day I was up early to meet the Political Agent's assistant, an Arab named Aidarous Ahmed Barakat. He had somehow managed to scrounge one of the Wadi's six precious Land Rovers belonging to the Desert Locust Control people, and was to drive me some 70 miles along the Wadi to Shibam. This delightful young man had been to a technical college in Devon and it seemed strangely incongruous to be talking about Torquay. We drove through ancient, picturesque Arab villages and then Shibam suddenly appeared in front of us. It is probably one of the most written-about places in Arabia. The centuries-old city is on the floor of the Wadi, with tall mud buildings huddled together skyscraper fashion, some of them sixteen storeys high or more.

It is impossible to drive a vehicle into the town, and we left it and walked up a ramp, through a massive arched gateway. From the large busy square in the centre, where people sell vegetables, radiate streets so narrow that only two or three people or a couple of donkeys can walk

abreast. The primitive sanitation arrangements of the buildings make it quite a dicey business to walk along; the waste pipes stick out of the walls and one acquires a sort of sixth sense to warn when danger is imminent. One can't buy an umbrella in Shibam. A few holes in the walls were pretending to be shops, but as far as I could tell not even the usual, simple things such as string or cheap Japanese ball pens were available—though the inevitable Coca Cola was. It was brought up here on the back of a camel. The picture I painted of Shibam must be unique.

Tarim, about thirty miles in the opposite direction, is a totally different place from either Shibam or Saiwun. Here the wealthier Arabs tend to live. Most of them, having made their fortunes in the Far East and Indonesia, returned here to build enormous, grotesquely ugly palaces, painted dazzling white and other colours. I suppose this is the same sad story of how outside tastes can influence an otherwise natural sense of design going back over the centuries. In Tarim, they have tried to copy Buckingham Palace and other mansions seen on their travels. Some of these huge houses even have wrought iron gates—laboriously brought up on camels from Mukalla. One house had four cars in its garage—although there are no roads in the Wadi and a Land Rover is about the only vehicle in which you can travel. The Sheikh's palace looked as if made of icing, a gigantic wedding-cake.

My last morning back in Mukalla was probably the most hectic of all. By 10.30 I had painted another 30in by 20in canvas, two bedouin police constables in attendance, to keep away the Arab children. I then flung the painting into the back of the Land Rover and we drove off along an appalling potholed track to the airstrip at 30-40 mph: apparently it was better to drive at that speed, but it could hardly have been worse. All four wheels of the Land Rover frequently seemed to leave the ground at once and

then bounce back again with a resounding crash. With a suitcase, a folding easel and two big, wet canvases, which must on no account touch each other, and having to hang on with one hand to stop myself being thrown out altogether, it was a test of strength and endurance. At the airstrip I watched my easel and paintings being loaded on to the aircraft and lashed down by the Arabs amongst beer crates, goats and chickens. Just in time I prevented a pile of dirty old sacks from being put down on top of one of the wet pictures. But the paintings survive to this day.

Once more back in Aden, the Commander-in-Chief offered me a flip round the Radfan Mountains in a two-seater Hunter. He promised me an armchair ride, but the strain of being strapped in so tight that I couldn't move, together with the intense heat, had a disastrous effect and I was sick all the way round. Somebody took a photograph of me stepping down out of the aircraft after the flight : it may have looked impressive, but I felt like death. Having shown me most of Arabia in a breakneck tour, the RAF then decided that, if I wished, they would fly me down to Kenya. So, off I trundled again in a dear old Beverly and arrived in Nairobi for what was now my second visit, this time as a semi-fledged artist.

The RAF people there commissioned me to paint a couple of Beverlys flying around the 17,000ft precipice of Mount Kenya. I pointed out that I couldn't really paint Mount Kenya unless they showed it to me, so they did. They laid on a Twin Pioneer, and having refuelled at Nyeri airstrip, we flew up and up—virtually climbing the side of the mountain. Indeed, the pilot whispered that it might be a good idea if I did not talk too much about it because the needle showed we were flying above the maximum permitted ceiling for a Twin Pioneer. Like a little bee flying round a flower, we circled on one wing-tip round the sheer pinnacle at the very top of Mount Kenya. It was

a spectacular experience and, in spite of being buffeted in the air current, I got some magnificent film and sketches. We must have been nearer to Mount Kenya than any other living souls have been, except the people who have actually climbed it.

Then I got a couple of commissions in Nairobi, and the RAF said, 'We don't really want aeroplanes, we fly them all day. Do you do local things like jumbos?'

'God, no. I've never painted an elephant in my life, but I'll have a bash!' And that is how it all started.

6 JUMBOS AND A NEW BEGINNING

Home, and first exhibition of wildlife paintings—success, and an Elizabethan farmhouse—'who wants to publish an elephant?'—Elephants in Boots—sex and an elm tree—a ship launch, a drink in a Liverpool pub, and a trip to the Far East—painting at Port Talbot, in my G-string—and a 707 of many colours

I arrived back in England flushed with the success of the Aden trip. The RAF had asked for a painting of a rhinoceros chasing a Twin Pioneer off a landing strip. I had done the sketches for this before leaving and that was my very first wildlife painting: I began to wonder if painting wildlife might have a future.

From notes taken at Amboseli on my earlier African visit, I painted my very first jumbo painting, and I took it down Piccadilly to Rowland Ward, the shop which sold sporting prints and trophies. Their reaction was not encouraging. 'We can't really sell big oil paintings of Africa, you know.' I persuaded them to take it and it was sold in a week. They asked for another.

About this time, Aylmer Tryon, who sold the pictures for Rowland Ward, started his own gallery, the Tryon, in Dover Street. Here, in 1962, my first Wildlife One-Man Exhibition was held. That exhibition not only changed my life; it bought us our lovely Elizabethan farmhouse. Robin Goodwin and his wife Biddy had bought a house in Hascombe, in Surrey, and one May evening when Avril and I had driven over from Frensham he suggested we all went to look at a house likely to come on the market. This was Winkworth Farm, glorious, half-timbered black and white, dating from about 1560 and dripping in wisteria

which looked almost the same age. And the beautiful courtyard was filled with flowers.

'Don't be bloody daft. We're not film stars.' But I telephoned the agents and offered them an absurdly low price, all we could raise. Needless to say, it was not well received. The bank declined to lend us anything like enough money to bridge the gap between what our Frensham house would fetch and what we might get Winkworth Farm for. When the house did come on the market, in November, it coincided perfectly with the opening of my show at the Tryon. Down came the most catastrophic fog that the country had seen for years and the few people who did look at the house were put off by the damp and the general dinginess everywhere: the late owner had expended his love and energy on the garden, and the house needed a tremendous amount of superficial work done. Moreover, it had suffered at the hands of the Victorians who, in the period of their worst possible taste, had covered up the lovely old oak beams with hideous black panelling, and filled in the inglenook fireplaces with ugly bricks and cast-iron grates with cherubs all over them. I can only assume that the few people who looked it over could not face the restoration, but to us it was a thrilling challenge.

My exhibition was opened by Peter Scott. It was an exciting evening. My bank manager was naturally a very important guest. A scrummage developed for the pictures and, in a hectic, unbelievable forty minutes, almost every painting had sold; all I can remember are snatches of conversation, such as, 'I've got this one. You have that one.' When the dust had settled, there were only three or four pictures left and the bank manager had changed his views about lending us the money.

We bought the house for a knocked-down price and set to, with sledgehammers, clearing the inglenook fireplaces and finding glorious Tudor cavities behind; and ripping

off the hideous black panels, to the screeches and screams of the woodworm, with a miniature Niagara Falls of timber preservative running down the stairs. Then came gallons and gallons of white paint and the house was restored to its original, lovely condition. Since I began painting and selling jumbos, my whole life has changed. We have this glorious house, 16 acres of grounds, with a lake, only 45 miles from London. My jumbos have done all this: there is an elephant weathervane on the roof to commemorate the fact.

The more I began to discover and paint elephants, the more I realised what fascinating animals they are. For an artist, a massive bull elephant gives immense scope. I can emphasise the thick, heavily wrinkled nose, almost 'sculpting' the paint; and then in contrast record the thin, veined and enormous ears. The skull of a big bull is a fascinating, undulating shape, offering masses of opportunity for the play of light and shadow. And of course the animal's tusks could have been added just for the thrill they give the painter—the subtlety and infinite variety of the shape and curve of a pair of tusks give endless scope for really three-dimensional effects.

Obviously, one or two other people began to catch the enthusiasm. I took one painting along to the publishing firm which had begun to adopt me in a small way. They had discovered me on the Embankment and published a few of my English landscapes, most of which had been either very slow sellers or disasters. Strangely they still had some faith in me, but when I showed them an elephant, they were slightly bemused: who would buy a fine-art print of an elephant? But they took the plunge.

'Lords of the Jungle'—I was not responsible for that nauseating title—was published in 1963, and immediately caught on. This was followed shortly afterwards by 'Wise Old Elephant', which was an even greater seller. Indeed,

this must surely go down in history as one of the best-known pictures of an elephant ever painted—thanks to the vast sales of the print made through Boots, the chemists. I was becoming known as 'the chap who painted that elephant in Boots' (and when jumbos come out of a river, they look exactly as though they have boots on). I had put elephants on the map.

With fine-art prints of 'Wise Old Elephant', 'Winter Plough', 'Elephants at Amboseli' and others I was 'in the charts'. Each year, the trade members—shops ranging from London's massive Selfridges to the local newsagent—assess which print has sold most copies. The winning subject may well be one of many hundreds each year, for the fine-art print trade is big business.

This was splendid for me in the early days. I wanted, and needed, to become known to a wide public and when the prints reached the 'top ten', as did those mentioned, this meant a very wide public indeed. The prints are run off in their thousands and can be seen in every branch of Boots and other chain stores. Anyone who is in the art business purely for money, and is doing it on a royalty basis, can make a fortune and unashamedly retire in a short time. One can think of a number of cases where an artist has thus ruined his reputation so much that his work is no longer wanted.

But this was foreign to my way of thinking. First, I wanted my work to be sought after for as long as I lived. And I was not being paid on a royalty basis anyway. I began to see the red light when at least two of my pictures were judged top of all the prints for a particular year. I even ousted poor old Constable with his 'Haywain' and Canaletto with his famous pictures of Venice—all hardy perennials.

Every art publisher in England was trying to jump on the jumbo bandwagon: 'We'll offer you a blank cheque for

the reproduction rights if you will let us "do" a jumbo.' It was tempting. I had children at expensive schools. But at this stage of my life, when clients were willing to wait many months for my originals, I knew that if I allowed further work to be churned out in unlimited numbers, whatever the quality, I would very quickly damage the demand for my original paintings. If I stayed in Boots the chemists, I might make a quick and considerable financial killing, but after a few years, my work would probably be worthless. This was not my idea of being a professional artist — art meant a great deal more than money.

I decided to issue only limited editions in future. The publishers were disappointed, but we agreed that I would do one more painting for the mass market. 'You don't have to put in any elephants, horses ploughing, seagulls, or anything else to pamper the public. Just paint what you like.' So I painted 'March Sunlight'. I still consider this to be one of my best English landscapes. It was painted with no thought of reproduction in mind, but as a plain statement of fact, a record of a subject I love as much as any other — the English landscape in winter, with bare elm trees and a watery sun. I delivered the painting to the publishers and they published it. I was fairly confident that it would not, thank heaven, get in to the 'top ten'. After all, it did not have an elephant in it.

Imagine my perplexity therefore, when the publishers rang me up one day at the end of 1967. 'You're not going to like this. "March Sunlight" has just been judged the top-selling print of the year.' Very flattering, but at the same time worrying. I was back in Boots the chemists again.

An artist always gets a fair amount of publicity when his work is 'top of the pops'. *The Sun* newspaper once carried a sickening headline: 'Out goes that Chinese girl, and now, so help me, you are buying elephants.' Everyone

knows the 'Green Girl' picture they were referring to. An evening newspaper wrote the most disconcerting rubbish about me 'earning £10,000 a year plus' from my prints, and as they were some £9,500 out in their estimation, I called them to ask where they got their information. As it was invented, they couldn't tell me. This sort of thing does not look good in print—apart from anything else, the taxman probably reads it! So I had a row—and discovered the unwisdom of being rude to the press. The next day they wrote another article about me, with a sort of veiled apology, but they added that I was difficult to get on with and rude.

As a matter of course, all the papers were sent a copy of 'March Sunlight' and a most odd piece of journalism subsequently appeared in one of the diary columns, under the heading: 'Sex Symbols'. It said that 'the symbolism is obvious to any amateur psychologist. The bursting buds on the elm trees represent awakening sex, and the icy pools of water in the gateway represent sexual longing.' So much for 'March Sunlight'—it has been known as my 'sex painting' ever since! David Frost read this nonsense, invited me on his TV show, and asked me if I could explain this interpretation of my picture. All I could surmise was that there was a chap on the paper's editorial staff who was either a sex maniac or a raving idiot. I was paid 40 guineas for that!

Now I knew it was time to get out of the mass market, but it was a hard decision to take. I am often told, 'You ought to be jolly grateful that so many people want to buy your prints.' I appreciate this point and realise that relatively few people can ever afford to obtain one of my paintings in a limited edition. But I had to think of my future as an artist.

Limited editions are the ultimate for which an artist can hope to strive. By virtue of its scarcity value, a limited

edition print is not only sought after as a piece of art, but also, in many cases, as an investment. This can surely only apply if the artist has made a name internationally, and today, having reached this exalted position, I am indeed fortunate. I allow two or three subjects a year to be published, in editions of 850 copies only, all signed and numbered. Almost every edition is bought out before it is even published.

Three or four years ago we published in a limited edition a print called 'Lion Majesty' at a retail price of £40 a copy. In the United States each of these copies now fetches somewhere in the region of £800. Although I do not benefit financially from this enormous increase in value, it is satisfying to know that my signature is worth something. It did not always mean so much. I painted a picture of Stowe School which was published in an edition of 500 copies, all of which were given to the school to raise money. Several years ago, at a Stowe Open Day, I sat at a table signing copies. Alongside me David Niven was selling his autograph, also in aid of the school. We were besieged by an enormous crowd and David muttered under his breath, 'For Christ's sake, do some of mine.' So, as bits of paper were passed over our shoulders from behind us, I was signing 'David Niven' as fast as I could and collecting two bob each time. I made more money for Stowe signing David Niven's autograph for him than I did selling my prints!

In the 1960s I was still painting a number of industrial subjects. I have always had a passion for machinery, although not in the least mechanically minded. As an artist, what I look for in such subjects as steam engines, aeroplanes, ships, steelworks and blast furnaces is the drama, the movement, the life and the character of machinery. But it is the older locomotives, aeroplanes, and ships which excite me. They have so much more character than their

more functional counterparts. And they evoke the qualities of romance and nostalgia. So I get far more artistic stimulus out of a Lancaster than a modern jet aircraft. And a British Rail diesel has little appeal; it is a purely functional machine. But any engine driver who worked with steam locomotives will tell you that they had personality and temperament. You treated them like human beings and got a response. If you kicked or caressed an engine, it would react accordingly. But if a fuse the size of your little finger goes wrong in the depths of a diesel that is the end of the matter. It is dead.

This character and life can be found in many industrial settings. I have been to heavy engineering works and steelworks, and painted blast furnaces. I may know nothing technically about what is going on in front of me, but I look at the scene as an artist and I revel in it. Shipyards have always held a fascination. I was commissioned to paint the *Transvaal Castle* on the stocks at John Brown's yard on Clydebank. It was a magnificent sight, with the huge liner in various colours of undercoat surrounded by all the scaffolding and massive dockyard cranes. At the launching, standing on the dais just behind the button, it was an impressive experience to see the ship's tremendous bulk towering over us and then gently sliding down the slipway. I was so carried away that, to everyone's amusement, I said, 'I wish they'd do that again!' That painting is now hanging in the ship, which has been renamed *S.A. Vaal*.

The trip to Aden was still paying dividends and many commissions were still coming in as a direct result of that painting of Slave Island. The Blue Funnel Line had asked me to paint one of their ships, the M. V. *Helenus*, coming up the Mersey, and this all started over a beer in a Liverpool pub. I was telling the Blue Funnel people about the trips the RAF were giving me round the world, and out of

this friendly discussion there evolved an extensive trip to the Far East. 'If you can get as far as Hong Kong with the RAF, we'll pick you up from there in one of our ships, show you the rest of the Far East, and you can give us a painting.'

'If I give you two paintings, can I take my wife?'

'Yes.'

The theory was that I would leave England in an RAF Transport Command Comet, carry out the work I had to do for the army and air force people in Malaya, Singapore and the Far East, and end up in Hong Kong just when Avril would be arriving there via BOAC. But I still had, it seemed, the jinx on 216 Squadron, and once again there were hold-ups all the way along the route. By the time I arrived in Hong Kong, Avril was half-way round Japan on the Blue Funnel Line. So I had to jump on a Japanese Airlines DC8 and fly to Tokyo, and then get on a train down to Kobe, where I finally met Avril.

We were both paid a shilling a day as 'crew' while we were on the ship, otherwise the unions would apparently have got rather upset. We had a marvellous trip all the way round Japan, Thailand, Vietnam, the Philippines, back to Malaya and then into Cambodia to see the mysterious and magnificent jungle temples of Angkorwat.

Among the industrial subjects I painted at this time was an exciting one at Port Talbot in South Wales, home of the gigantic complex of the Steel Company of Wales. I was commissioned by Davy United, its builders, to paint a 'continuous strip rolling mill'. This is a process where steel comes in in enormous great lumps, red hot; it goes through the machine, about the size of a house, and while molten is turned over and patted several times like a pat of butter; it then comes out the other end at breakneck speed, rolling along the rolling mill track which stretches a quarter of a mile down the shop. It was an enormously stimulating sub-

ject to paint. The heat and the noise were tremendous and, with sparks flying in all directions, I had to wear a safety helmet. The best vantage point was up in the girders of the factory wall. I must have looked an extraordinary sight, perched up on a sort of cat-walk thing right above the ground, dressed only in a G-string and a helmet.

I was still painting aircraft. A picture of a Capital Airlines Viscount flying over the skyscrapers of New York led to an indication—although it was not a definite commission—that TWA might be interested in a similar panorama of New York with a Boeing 707 in their colours. Like a fool, I did the painting on spec. It was an enormous undertaking. The canvas measured 8ft by 5ft and showed a complete bird's eye view of the whole of Manhattan Island and the surrounding districts. TWA were not interested in buying it, although they did display it in their London window, in Piccadilly, where it certainly drew the crowds. In a fit of pique I obliterated the Trans World Airlines livery and substituted that of BOAC in anticipation. But BOAC weren't tempted either and the aircraft remained anonymous for a long time. Of all my paintings, this one has had the most chequered history—in fact it nearly started a third world war. After several more changes of livery in various airline colours, and with the white paint on the 707 getting thicker and thicker, I finally decided to attempt to sell the painting to the US Air Force. So the 707 became a Military Air Transport Service aircraft and, whilst the US Air Force did not exactly express an intent to purchase, they did offer it a semi-permanent home in the entrance hall of their headquarters arrival building at Mildenhall in Suffolk. The painting hung there for several years, where it obviously did me a lot more good than if it had languished unseen in the attic of my house. But then, amazingly, a US Air Force general came

over from the States and happened to see the painting hanging in the terminal building.

'Gee, we must have that work of art for the Pentagon.'

I offered the painting to them at a knockdown price and received a friendly letter in return stating that their policy was that, if paintings were donated to them, the US Air Force would fly the artist anywhere he wished to go within their sphere of command.

'OK. If I give you the painting, will you fly me to India?'

'Yes, providing you give us another painting of India when you have been there.'

'Come off it, chum. You said one painting for one trip. Now you're asking for two paintings.'

It may have been a bit bloody minded, but I was busy at the time and not that desperate to get to India. And so the matter should have remained, on a fairly friendly basis. After all, the painting was still hanging up at Mildenhall and everybody seemed happy. But one morning Reuters Press Agency phoned: 'Can you tell us a bit more about this war you're having with the US Air Force? We want a story for the international press.'

'What war?'

'Haven't you seen the *Daily Mail* this morning?'

I hadn't and, on Reuter's suggestion, went down to buy a copy. 'Artist Opens Fire on the Pentagon—Pay Up for My Picture Or Else' was the heading of a 9in column. The reporter claimed that I was going to threaten the Pentagon with a lawsuit if they didn't buy the painting. I had a sinking sort of feeling that the thing was sliding out of control. Sure enough, a couple of days later, when having lunch with Westland Aircraft at Yeovil, I was interrupted by a phone call from a major newspaper who wanted to stir things up even further. And most of the other papers joined in the fray. Where was it all going to end? A few

evenings later a very senior US Air Force officer phoned me about midnight from their headquarters at Ruislip in Middlesex. 'Is that you, Dave? You've nearly lost me my job. The Pentagon wants to know what it's all about. They've just phoned me and I don't know what to tell them. I'm in deep trouble. What are you going to do about it?'

'Look, chum, it's nothing to do with me. I didn't start all this. You've got your sensational press in the States just like we have, and you ought to know they'll stir up anything to make a story.'

It only needed the Russians! It seems incredible in retrospect that phones could start ringing from across the Atlantic over such frivolities. The whole thing had started off as a friendly gesture when I lent them the painting. The next thing was that, presumably as a result of the notoriety now attached to the picture, I received a cable from a total stranger in the States: 'Will you sell disputed airliner painting?' It turned out that this generous gentleman was prepared to offer me a sum below the actual cost of sending the painting out to him.

I finally received a blunt order from the USAF to remove the painting forthwith. Three years later I collected it and just fitted it in under the rafters of the garage. The pigeons started nesting in the roof just above it and the Statue of Liberty began getting splashed. But the story has a happy ending. The 707 of many colours was finally bought by a chum of mine for his office in Farnham. I scrubbed off all the pigeon muck and it looks as good as new. Oil paintings are remarkably tough.

Sometime in the 1960s, my publishers thought that a painting of London from the air might be an interesting subject for a print. Only I would have been mad enough to take on such an assignment. To make the task harder, I decided to do the painting on a canvas 15ft long by 8ft

wide. The research for this was enormous. Photographs from a film library helped, but no single photograph could ever have given me the wide angles that could be put on a canvas of those dimensions. So I had to work from a couple of dozen, taken at different periods, some before and some after the war, and at various heights; it raised the most appalling problems of perspective. I had to imagine, when looking at one particular photograph, how it would have appeared had the aeroplane been a mile to the west and 1,000ft higher. I also had to be careful to date it correctly. The Festival of Britain site had just been cleared and the Shell Centre was going up. Blitzed buildings and cleared sites had to be omitted. Every pinnacle and every window of the Houses of Parliament and all the buildings in the foreground along Westminster Square had to be included.

The whole job took three weeks and nearly gave me a nervous breakdown. Towards the final stages it became one hard, mechanical slog. And, owing to photographic problems, I had painted the river too wide. When I thought it was finished, a chum of ours, who looked after my mother's pigs, came into the studio in his hobnail boots. He had not looked at the painting for more than a few minutes, when he pronounced: 'You've got one arch too many in Waterloo Bridge.' My reaction was to chuck him out of the studio. Yet he could be right. I checked — and he was. In getting the river too wide, I had inadvertently added an arch. If the thing had gone to print like that, the publishers would have been inundated with protests. So I had to stretch the bridge.

After being published as a print, the painting came back to the publishers' office where it languished for many months, covering most of the wall. Finally, my friend in Farnham bought it. 'London' now covers one wall of his office, and the 707 of many colours the other.

7 STEAM-AGE LOVE AFFAIR

Steam in my blood — Rembrandt would have been a steam railway enthusiast — I paint steam in its death-throes — the preservation bug bites — I become the naive owner of 240 tons of engines with no home to go to — in search of a railway — a dream comes true, and Black Prince *helps to raise £10,000 for wildlife — an old lady comes back from Africa*

The people who live in the North London house where I spent my early childhood may wonder why the chimney smokes in the best bedroom. I can tell them. It is because trains used to run through it before the war. My father had a beautiful O-gauge model layout, and to achieve a more realistic curve between Euston and the North, he bored a tunnel through the chimney. And we couldn't light a decent fire downstairs. Steam was thus born in me.

As a small boy I never was one to stand on draughty platforms taking train numbers. The excitement of steam railways came to me through the eyes of an artist. If Rembrandt had lived in the railway age, he would have been a railway enthusiast revelling deeply as I have done in the smoky cathedral interiors of the steam sheds. His sombre colours would have been so beautifully suited to the portrayal of these marvellous scenes which have now passed into history.

I am often asked what subject I love painting the most. This has to be it. Not for me shining locomotives, hurtling out of the canvas, as in so many photographs. The steam age was, for me, inside the sheds. And the engines were grimy workhorses, in the twilight of their years, neglected, forlorn, but still working. Here, in the gloomy depths of a roundhouse, was intense beauty of the most dramatic kind

if you looked for it, through the dirt and grime. Shafts of sunlight penetrated broken panes of sootcaked glass in the roof, through the steam and smoke, and played on pools of green oil on the floor. Lovely harmonies could be found in the cool greys and browns and mauves of the grimy engines; and on the connecting rods one could detect the occasional glimmer of brilliant light where wet, slowly dripping oil caught the sun. All was almost quiet as the great steam engines were at rest ready to go out on the road. The occasional wisp of steam would eddy up into the darkness of the roof and there would always be a murmur of gentle sound as the engines simmered.

My happiest painting moments were spent in those vast sheds at Willesden, Swindon and York which have now passed into history. The men, coming in to work, would pause a while and look and think. They had probably never before seen an artist mad enough to dress up in about six sweaters—the cold was killing—and stand all day in pools of oil, surrounded by great steaming locomotives. But this was the only way to get on to canvas the subtlety of it all. They would comment; I would take note of their informed criticism. One could take no liberties with the technicalities of an engine if they were standing right behind one. Being an artist was no excuse for doing so. 'Cor, it's just like the real thing,' and I knew I had passed the test.

In 1955 I painted a number of pictures that are now part of the National Collection in York Museum. But from then until 1966 I had been too preoccupied with earning a living to give railways a thought. How many opportunities I must have missed of sketching what would now be history—steam engines were all around, and some of us didn't notice. By 1966 the railways were bent on a fanatical rush to dieselise. Brand new steam engines were being thrown away only five years after they were built. Steam

'March sunlight' (*by courtesy of Solomon and Whitehead (Guild Prints) Ltd*)

The Second Battle (from the 'War Art Room' in The Imperial Institute of...)

'Rambo'

'Avril'

'Christ'

'Nine Elms' (by courtesy of Solomon and Whitehead (Guild Prints) Ltd)

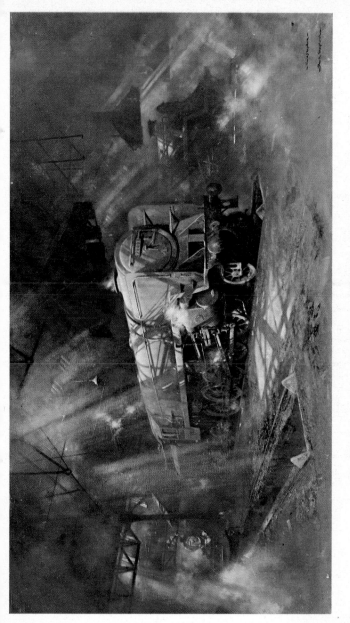

'On Shed' (by courtesy of Solomon and Whitehead (Guild Prints) Ltd)

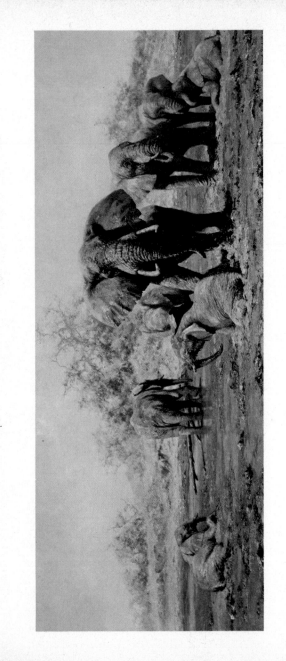

'Elephant Heaven' (*by courtesy of Solomon and Whitehead (Guild Prints) Ltd*)

locomotives were going to the graveyard at the rate of hundreds a week. Steam was going and it was going fast. The result of all this was an explosion of railway interest amongst the—by that time—very considerable railway fraternity in the country. I at once became caught up in it in a much bigger way than I could ever have imagined. My interest in steam locomotives was revived, passionately, at the eleventh hour.

In 1967, I was working to capacity to complete a large exhibition of wildlife paintings for a one man show in New York. In spite of painting elephants all day, the magic pull of Guildford and Nine Elms locomotive sheds, then in their death throes, finally became irresistible. I found myself hopping into the car and driving up to Guildford and looking longingly over the bridge at the steam shed. I had never been in there and it had only a few months to go. Finally, I could bear it no longer. I found myself painting elephants with one hand and almost literally sketching locomotives with the other. I would dash along to Guildford in odd moments and record on canvas in a last feverish rush something of the fast vanishing steam era. And I would somehow manage to squeeze eight or ten days into every week and take time to go up to London and sketch at Nine Elms, the great steam shed for Waterloo.

It was at Nine Elms, incidentally, that a piece of history was captured on film for posterity. I was in the depths of the steam shed, surrounded by engines lingering out their last days in steam, trying to record something of the scene. The shed was falling apart around me. The engines were being towed away as I painted them, to be melted down into razorblades and Toyotas (a lot of the scrap went to Japan, from where it returned!). A friend, Paul Barnes, happened to wander in and saw a marvellously evocative and nostalgic story to be recorded. Together we made a little masterpiece of a film called 'The Painter and the

Engines'. It was given its world première at the National Film Theatre in London, and is now in the British Film Institute's archives.

I am proud that one of my best-known railway pictures came out of those hectic days at Nine Elms. Entitled 'Nine Elms, the Last Hours', it portrayed the final minutes of steam in the whole of the South of England on Sunday 7 July 1967. In the foreground, an almost new BR Standard 5 stood rusting, forlorn and forgotten. I chose this engine for sentimental reasons. It was on her that I had many happy and illegal footplate trips on ballast trains around Guildford. Behind her, about to drop her fire for the very last time, was one of the magnificent Merchant Navy class Pacifics. She was the last steam engine to go into Waterloo. Both engines were chalked with sentimental, corny, but always sincere slogans from enthusiasts: 'Steam for ever', 'Farewell but not forgotten', 'For sale, 9/6 and 3,000 green stamps'. Around the locomotives were all the filth and squalid impedimenta that marked the end of Britain's great steam heritage—rusting old firebuckets and firing irons and ashes—general degradation was everywhere. But this is what it was really like. We threw away our magnificent steam age as though we were ashamed of it. It died an ignominious death.

I never sell my railway pictures. They mean so much to me in terms of affection that I cannot bear to part with them. Moreover, with the pressure of other work, I have so little time for what I call 'relaxation painting'.

In 1969 in Johannesburg, I had one of the biggest exhibitions of my career. It included paintings that covered every sphere of interest. Apart from a little nude, a couple of Spitfires and scenes of London, there were, of course, a number of wildlife paintings. And I also sent out my seven railway pictures, though these were not for sale. At the close of the exhibition they were all packed up in a Dur-

ban warehouse ready for shipment back to England when the entire building went up in flames. I lost all my railway pictures except one—the painting of Germiston steam-sheds, Johannesburg, had been retained by the gallery, by mistake. If they had done everything as I had asked, I would have lost that one as well. And all these paintings were irreplaceable. 'Nine Elms' was one of them, and also the historic painting I did in York sheds, painted in 1955, and which was owned by my mother.

I had done a number of little cameos and quick working sketches in Guildford and Nine Elms sheds which are now beyond value to me. They are authentic, because they were done on the spot. Some only took ten minutes, but even this was enough to record atmosphere—which was all I was striving for. Together with countless photographs which I took to record the shapes, I also have these little sketches to give me the colour. So, over the rest of my life, which I hope will be a long one, these will enable me to sit down and paint shed scenes which really portray the steam age as I and so many others remember it.

It was at Guildford and Nine Elms, too, that I got the preservation bug. I was meeting desperate enthusiasts who, like myself, had to save something, somehow, of the fast vanishing age of steam. I began to dream. I had not much time left and almost overnight the idea developed that I might actually be able to own my own engine. I must have had enough foresight and common sense to realise that, if I was going to venture into this almost un-real world of owning mammoth pieces of machinery, I at least ought to try and get an engine in reasonable working order. There were still quite a few BR Standard Class 4 mixed traffic locos around and, from a short list of three or four, I chose 75029. She was still in service at Wrexham and for the princely sum of £2,800, in full working order, with an almost new boiler, she became mine.

People say I act on impulse. I think this is the best way to do things. My 1967 New York exhibition sold out on the first evening. I came home and in an elated frame of mind at once telephoned my British Railways friend at Stoke-on-Trent: 'Can I have a 9F as well, the best available?'

I must have sounded a bit of a lunatic over the telephone—and there were plenty of lunatics around at the time. We were buying engines as though they were packets of sweets. British Rail deserves credit for taking us seriously at all. 'You're in luck. We've just done up 92203. She's probably the best 9F we've got left.' They still had about seventy of this class at that time. 'We've just painted her up and selected her to run the last steam-hauled iron-ore train from Liverpool Docks to the steel works at Shotton. You can have her if you like.'

This strange phone call resulted in her immediate withdrawal from Birkenhead shed. She was sent straight down to join 75029 in the back of Crewe South locomotive shed. I was now the proud but naive owner of two enormous main-line steam locomotives, collectively weighing some 240 tons.

For £3,000, 92203 had become mine. I will never forget the first moment my eyes fell on her. Picking my way between rusting lines of grimy locomotives waiting their fate in the scrapyard, I came round the corner at the south end of the shed and there was my huge gleaming black locomotive in steam. She had just that moment arrived. Nearly 70ft long, and weighing 140 tons in full working order, she glistened in the evening light. I was a happy man.

I used to go up to Crewe and stand alone in the crumbling, decaying shed. Its days were numbered. Soon the bulldozers would move in and another piece of history would be flattened. The last steam engines would be

towed away—and my two locomotives were awaiting my collection. I owned every inch of them and I did not have a railway. I had the receipt in my pocket, with an eviction order, and nowhere to go. And I began to worry. The truth was beginning to dawn, and the engines were big and heavy.

It was through one of those funny twists of fate that a home was found for them. My elephants had paid for my locomotives and 'Christ' now found them a resting place. I am not particularly religious—but I shall always be grateful to Him! It all arose out of the reredos I painted for Bordon Memorial Garrison church. A few miles away, at Longmoor, there was an extensive military railway system, built in the 1920s, clearly with room to spare. Over drinks with one of the colonels who had been responsible for negotiating the memorial reredos painting, I happened to mention that I was the owner of a steam engine without anywhere to put it. At that time I had not yet bought 92203.

'We've got an old Nissen hut down at Longmoor with a railway line into it,' he said. 'We might tuck her inside there, if you like, all a bit unofficially.'

The War Office was very co-operative and the locomotives were given a home at Longmoor, together with those which had been purchased from Nine Elms by some of my chums.

The question of moving the locomotives from Crewe to Hampshire reared its head. It might appear to be a simple matter of just driving the engines down the railway line—after all, they were in full working order. Unfortunately, I was confronted with the less attractive face of British bureaucracy, to whom the simplest way is not necessarily the easiest. Steam was still around on the Midland Region at this time, but, no, 'they must be towed by diesel'. The

price quoted for this humiliating suggestion was right through the roof.

Changing the mind of British Rail took eleven months. During this time there were some splendid headlines, such as, 'Artist fights for the dignity of 92203 and 75029.' At one stage BR told me I could light the locomotives up but, although they would be in steam, they would still have to have a diesel in front. I decided to pull out the last stop and write direct to the chairman of the Board, and a telephone call a few nights later assured me there was no need to have a diesel in front. Common sense had prevailed.

The engines were to set out from Crewe on Saturday, 7 April 1968. We spent the previous evening in the locomotive-power depot and were very busy. With the aid of all the marvellous BR people in the shed, who were as keen as I was to see 92203 and 75029 kept in working order well into the future, we were digging holes in the coal piled up on two tenders—and burying spare parts! The story can now be openly told, I am sure, without upsetting anybody. The spares were going to be thrown out as scrap, but they were far more valuable to us and everyone in the depots and management of BR made sure we had a plentiful supply of everything available in these last days of the steam age.

I was up early the next morning and the BR crews— who, I am convinced, would have done the job for nothing —were already on shed at 7 am getting the locos finally prepared. Then off we went down the main line, via Leicester, Derby to Cricklewood. There we were tucked up for the night in the diesel depot.

I always remember the depot manager coming to greet us. He hopped up on to the cab of 92203. The engine had burnt more coal than she should have done on the way down and, when he looked into the tender, all he could see was a large pile of valuable brass spare parts. 'What

the hell is all that? Where did all that come from?' I saw a twinkle in his eye, however, and within the hour we were all rooting around in his depot and dug up more bits and pieces which I am sure he did not even know he had. And in it all went, quite unashamedly.

The next day we journeyed on to the Southern Region to Liss. It was a very special thrill to see my very own two steam engines going through my home town of Godalming. They were the first to do so since the end of steam.

We finally arrived at Longmoor, where my engines and those of my colleagues were to stay for a couple of years in the good hands of the army authorities.

When the time came for us to get out, British Rail came to the rescue, finding me a siding alongside the diesel depot at Eastleigh. I was charged £20 a week, but at least it was secure — there is nothing like electrified rail for keeping away thieves and vandals. The engines spent well over two years there. As on previous occasions, we came to know the local BR people and got away with a lot that should not be recorded in print. But it was not much fun sitting in a siding, out in the rain, at £20 a week. This was supposed to be a hobby — and this emphasised just what an expensive one it is. We were getting desperate. My chums and I looked at thirty-one different sites in the south of England.

In the end, we found one near Shepton Mallet, in Somerset, at a little village called Cranmore. Land was available and, thanks to the dear old jumbos again, I was able to build a railway locomotive shed that looked like the real thing. Indeed, I think it can justifiably claim to be one of the finest in the country. It follows closely, down to the finest details, the traditions established by the great Victorian railway builders. We have built from the ground up a magnificent brick building, 130ft long, with two tracks

inside and an inspection pit, and 4,000 sq ft of workshop adjoining it.

I am now building up my very own steam railway. We have been given permission to trade under the original name of the East Somerset Railway, which began life on 9 November 1858. It ran through Cranmore to Shepton Mallet and beyond to Cheddar and Ilfracombe. Most of the branch line was removed long ago. Cranmore, the only original station remaining along the length of the line, was built at the time of the opening of the railway. We are now restoring it to all its original charm. What I am trying to do, with my colleagues, is to keep alive something of the past, in a way that is entirely non-commercial. Each helps the other, and all the labour is voluntary: I provide a railway on which my helpers can have an outlet for their constructive energies that appeals to them; and they are giving me their labour. It works extremely well both ways.

When the public visit preserved railways and steam depots, they understandably have little idea of the blood, sweat, tears and drama that have gone on behind the scenes to achieve the successful steaming and operation of a mainline locomotive. How can they? All they see are the shiny locomotives giving footplate rides to happy children.

Some twelve good friends of mine came into the railway preservation business with me right at the beginning, and they have stayed with me ever since, through thick and thin—and most of the times, up to the establishment of our railway at Cranmore, have been very thin indeed. This basis of mutual help, trust and understanding is a very sound one on which to build and develop such an exciting project. When, on June 20 1975, Prince Bernhard of the Netherlands, the International President of the World Wildlife Fund, came to open the railway officially, we raised £10,000 for the fund. So we are helping not only to preserve steam engines, but also to conserve wildlife.

IMMEDIATE ACTION

—

𝔐inute by 𝔥is 𝔈xcellency

HON. A.J. SOKO, M.P.,
<u>MINISTER OF POWER, TRANSPORT AND WORKS.</u>

 This is to let you know that I endorse the
decision taken to sell one of the locomotives that
belong to the Zambezi Sawmills to Mr. David Shepherd.
The Government has also decided to give him one
free of charge. The two locomotives concerned are
Nos. 993 and 156.

2. This minute also serves to allow him to
take these engines through Livingstone. I have
given this authority because this action will not
break sanctions in any way at all.

<u>10th August, 1974.</u> PRESIDENT

cc. His Honour the Secretary-General
 Rt. Hon. Prime Minister
 Hon. Minister of Foreign Affairs
 Hon. Minister of Planning and Finance
 Hon. Minister of Home Affairs
 Hon. Minister of Mines and Industry
 Mr. David Shepherd.

Authorisation from President Kenneth Kaunda.

Amusingly, it was my game-warden friend Rolf who first told me about the Zambezi Sawmills Railway. In his days with a safari organisation, Rolf had an enormous piece of Zambia as his hunting area, into which he could take his clients; there were no tracks and no immediately recognisable features in the hundreds of square miles of bush, but he knew it like the back of his hand. On one occasion he was out in one of the remotest corners of this vast wilderness, with an American who had a licence to shoot a lion. The two of them were in the final stages of stalking the animal; the heat of the hunt was mounting, the visitor becoming more and more excited as the lion was just a few hundred yards ahead of them.

All of a sudden they came into a clearing. And there, in absolute peace and tranquillity, shafts of sunlight breaking through the trees, stood an old steam locomotive, entirely on its own with not a soul in sight. All that could be heard was a gentle escape of steam. The American could hardly believe his eyes. They had come to the Zambezi Sawmills Railway, and for the rest of the day the visitor spent his time climbing over the engine and photographing it. He forgot all about his lion.

It was in 1964 that I first went to Livingstone, in the southern part of Zambia—a quaint old colonial-style town. Driving down the road to the Victoria Falls, on the left I could see smoke rising from the roof of the Zambia Railways steam shed. Leaving the car I walked into the shed and was nearly arrested. 'Have you got a permit?'

'No.'

'Come on, hop it.' The shed master in those days was still an Englishman.

'I do have two engines of my own. Do you think you could let me be a bit of a special case and have a quick look round?'

The shed master looked quizzical, and then light

dawned. 'You're not—you're not that artist bloke, David someone-or-other?' Five minutes later I was driving one of the enormous Zambia Railways 20th class Garrett locomotives up and down outside the shed. Over the road was the Sawmills Railway's headquarters, then still operating independently to serve the sawmills at Mulobezi, 110 miles up the line from Livingstone. An incredible line of ancient locomotives was sitting at the Livingstone end; some were being swallowed by the bush, yet were still complete with gauges, brass builders' plates and whistles. 'We're going to repair those engines some day—but it's awfully difficult to get the parts,' the general manager told me. As the engines were all second and third hand from South African or Rhodesian Railways, dating from as early as the 1880s, this was not surprising. But sure enough, when I went back several years later some of them had been towed up to Mulobezi and given a new lease of life.

In 1974 a full-length documentary on the line was made for British and American television, for which I did the narration. And what evocative material the line provided up at Mulobezi! We found ancient steam locomotives dating from 1870, old coaches rotting away full of puff adders, waggons from 1920; even an old Ford Prefect with railway wheels fitted for use as an inspection trolley was dug out of the bush for us! But days after the filming, the line was taken over by Zambia Railways for modernisation, the sawmills closed. I could not bear to see the locomotives left to decay, and asked if I could have one. No 993, built in Glasgow in 1896, in full working order, the best Class 7 they had, became mine—as a free gift, with spares. I also acquired, for a knockdown price, the *Queen of Mulobezi*, their main-line Class 10, built in Glasgow in 1922; and a beautiful 1927 sleeping-car, with wood panelling, washbasins and green leather bunks, was thrown in for free.

So there was I with two large steam engines and a coach in the heart of a landlocked African country. How on earth could I get them home? We started investigating the possibility of taking them over the bridge into Rhodesia—the famous Victoria Falls bridge which spans the Zambezi River and forms the Rhodesia-Zambia border. This border is one of the most delicate in Africa, dividing black in the north from white in the south. Though local customs officials assured me that they could be classified as my 'personal effects'—all 200 tons—I did realise that some higher authority was needed. Fortunately, through knowing President Kaunda, I was able to get a letter to him and was invited to fly out to join him in the Luangwa Valley, where he was taking a rare holiday. His personal blessing to my request to take the engines 'over the bridge' took the form of a State document, for 'Immediate Action'. With the help of everyone on both sides of the border, the locomotives and coach made their historic journey down to Bulawayo. There the Class 10 had, reluctantly, to be stored; the Class 7 and the coach journeyed down through Mozambique to Beira to await shipment. Eventually they reached Manchester, and through the good offices of the Zoological Society of London they have found a temporary home on the Umfolozi Light Railway at Whipsnade Park Zoo; once again steam engines and wildlife have come together. Eventually they will come to the East Somerset Railway.

8 WILDLIFE SOS

Wildlife conservation, and I become aware—a painting gives a jumbo a drink, and another saves one-and-a-half cross rhinos—happy days with the game wardens—nuns up a tree—Daphne, Eleanor, and friends—hunting, and hilarity at base camp—the awful cost of a leopard coat, and other poaching horrors—a Bell Jet Ranger—'Tiger Fire'—my first (and last?) wild tiger—'African Afternoon'

I have a passionate belief in the conservation of wildlife and wild places. The appreciation of wildlife has broadened my horizons and increased my perception of life in general. When I go to a national park, and sit on a river bank and watch sixty or seventy elephants playing in the water, I always feel that this is what really matters—to me, anyway. This is the stuff that life itself is made of. At such times, it is remarkably easy to push politics and world affairs right out of one's mind, and feel better for it.

When I first went to Kenya in 1950, in that abortive attempt to become a game warden, I scarcely knew the meaning of the word 'conservation'. Nobody in those days knew just how fast some species were being decimated and wild places desecrated in the mad, greedy rush for financial gain. And only a handful cared. Only in the last ten years or so has conservation come to mean anything. And, now, thank heavens, a lot more people care.

I have learnt a great deal in those ten years, from personal experience. In order to paint new pictures and get fresh ideas I have to visit Africa regularly, two or three times every year, and the more I go, the more I get right into the whole business of wildlife conservation where it is all happening. In the days of my first visit it appeared so

idyllic. Jumbos were feeding peacefully, and zebras drinking at the pools and waterholes. But there was a lot happening in the background even then which I didn't see.

About two or three years ago I received a letter from Myles Turner, then Senior Warden in the Serengeti National Park in Tanzania. One of the best-known nature reserves in the world, it is visited by thousands of tourists every year. Any day of the week the zebra-striped minibuses go round the park full of happy tourists on their 'see Africa' package tours. They come to a waterhole and sit happily in the bus filming the idyllic scene — the impalas, zebras and other species coming down to drink in the heat of the day — and all seems fine.

What they don't know is that there may well be another waterhole a couple of miles away which would show them a very different picture. Myles wrote: 'Found 255 zebras dead round a waterhole last week.' He went on to describe the ghastly scene where countless carcases of other animals too — giraffes, impalas, gazelles and hyenas — were lying, all victims of one of Tanzania's worst poaching rackets. The waterhole had been poisoned. The Asian who perpetrated this revolting crime — he was caught soon afterwards — had obviously considered it more practical and cheaper to poison the water than to go out shooting zebras. He wanted their skins to sell on the black market. The fact that all the other animals died as well did not concern him. Myles and his colleague Eric Balson, head of the game departments, exposed the racket. Eric's wife had to take a revolver with her when she went shopping — her husband was the number one poacher-catcher.

This was the sort of situation I began to discover. I wanted to do something for the wildlife of Africa in return for what it was doing for me, and quickly realised I could raise money by donating and auctioning my wildlife paintings.

The first painting I donated was of jumbos at a water-hole. There was a splendid scheme at the time called the 'Water for Wild Animals Fund'. The idea was to raise money to build artificial waterholes and irrigation schemes in otherwise dry parts of East Africa, to attract wildlife into these areas. Such slogans as 'thirty bob keeps an elephant in water for a week' were used and the money came in. My painting raised £200. It perhaps gave a few thirsty jumbos a drink. But conservation is a delicately adjusted business. Having received 30s donations from numbers of well-meaning ladies in England, to keep the elephants happy, ten years later a number of these same elephants had to be shot as part of an experimental culling programme thought necessary because of their apparent destruction of the park environment.

I gave another painting, this time of a lion, to the East African Wildlife Society who were helping to organise the Rubondo Island Scheme. Their plan was to rescue rhinos from areas where they were being poached. The poor old rhino was, and still is, under sentence of death because of its valuable horn. This fetches a very high price on the Far East market because the Chinese still have the misguided idea that powdered down rhino horn forms an aphrodisiac. God knows why the Chinese want an aphrodisiac . . .

The whole scheme had a touch of the Wild West about it, and Hollywood westerns would seem tame when compared with the real life dramas being enacted to help save the poor old rhinos. The animal would be drugged with a tranquillising dart, probably miles away from the nearest track and, before it woke up, it had to be reached by truck, winched up into a crate and driven like the clappers to the shores of Lake Victoria. The crate was then put on a ferry and taken across to Rubondo Island. And rhinos are not in a very appreciative frame of mind when they wake up

after this sort of treatment. Rubondo Island had been set aside as a rhino sanctuary. The plan was to let the rhinos breed up to a reasonable number and then bring them back on to the mainland once the original areas were cleared of poachers. The lion painting raised £1,500 and I like to think that it has given safe sanctuary to roughly one and a half rhinos.

But I was able to go on to bigger things and, if this appears to be a boast, it is sincerely the greatest thrill of my life that I can raise money for wildlife so easily; the total to date is some £300,000. I am a compulsive painter and have to paint every day; but no one wants to paint all the time for the benefit of the government via taxation, so it is simply a case of diverting the proceeds in another direction. It is infinitely more satisfying to donate the painting to the World Wildlife Fund, so that the rhinos or the tigers are the ones who benefit.

As my visits to Africa increased, the more I learned. The old guard of game wardens became my greatest friends. These dedicated men are among the many unsung heroes of wildlife conservation, and played a huge part in helping to save the wildlife of Africa when they stayed on after the colonies became independent. Not only did they rightly have faith in these African countries, but they were so dedicated to their work that, although so badly paid, the development and consolidation of the national parks system became their whole life. Over the last twenty years these game wardens have taken me in their Land Rovers into the remote areas not visited by the ordinary tourist, much closer to the wildlife than is normally possible; and they have told me what goes on behind the scenes. I have learned a lot, have seen for myself, and have had some hilarious times.

Tuffy Marshall, who had taken me down to Amboseli on my first African visit and shown me my first jumbo, was

warden for Tsavo West Park in Kenya for many years. A quiet man, with the bearing of a colonel, in his faded bush shirt, long trousers and a tatty old bush hat, he was never happier than when quietly smoking his pipe, watching animals. He had that wonderful affinity with the bush in which he lives, a characteristic of all the old guard of game wardens—Tuffy, George Adamson and the others. The life of a game warden, like his popular image, is often highly romanticised. He must spend a good many hours, for instance, behind a desk doing the paper work. On so many occasions, having driven down from Nairobi, I have called unannounced at the Tsavo Park game-warden's house, knocked, and to a gruff 'come in' cautiously opened the door to find Tuffy buried in paperwork. He would look up and, without a word being said, would light his pipe, sweep the papers on the floor, and within five minutes be happily driving me out into the back of beyond in his beloved old Land Rover. I had no guilt about interrupting him; he needed this incentive to get him away from his desk.

He would regale me with wonderful stories about tourists. 'Have you heard the one about the nuns up a tree? Went out the other day right over to the other side of the park, came round a corner—and there were a couple of nuns, in full habit, sitting up a tree, with a rhino at the bottom. Turned out that three of them had driven into the park in their car, and these two said they'd like to be left so that they could have a better look. So they'd climbed up the tree and the third one took the car away. They didn't know a rhino was going to come up and investigate. It was fascinated—it had never seen a nun before and it wouldn't let them out of the tree.'

'Had a ghastly blue-rinse woman from Texas here the other day. She asked me if we had polar bears in Tsavo Park. I told her yes, we did have a few, but this was the

hot weather and they'd all gone up into the hills. She seemed quite happy.'

Once, in the middle of a funny story, Tuffy suddenly swerved the Land Rover right off the road, and nearly hit an old bull jumbo placidly feeding by the roadside. Back on course again a few seconds later, I questioned Tuffy's driving. 'Didn't you see the tortoise crossing the road?' This seemed to sum up the whole attitude these marvellous people have towards wildlife: it wasn't sentiment—they loved the wild environment in which they lived, and every part of it.

I have had some wonderful wildlife sessions with George Adamson, too, up in his beloved Northern Frontier District of Kenya. One memorable afternoon was spent sitting on the banks of the Uaso-Nyiro River, where sixty elephants were playing. They were standing on their heads, washing their babies, cavorting in the water and getting on with the business of being jumbos. George was, as always quietly sitting on the bank smoking his pipe. Not a word was said. The human voice would have been horribly irrelevant in a setting like this. Much of that afternoon, in fact, I was watching George. This was a scene he must have seen on countless occasions, but he was drinking it in as though it was as new to him as it was to me.

Some of the most enjoyable and memorable experiences I have ever had in Africa have been with David Sheldrick and his wife Daphne. More than twenty-five years ago David was made warden of Tsavo National Park East, then virgin Africa. The bush was so thick one could scarcely walk into it. Some 4,000 square miles were dumped in his lap and he was told to get on and make it into a national park. A task of such forbidding dimensions would have dismayed and broken a lesser man, but he set to with utter dedication and has since turned it into one of the finest parks in Africa.

The public can drive through Tsavo Park and occasionally someone may find a baby zebra whose mother has been killed, or a lion cub deserted by its mother. When the baby animals have been picked up, the first person they go to is the game warden's wife. The orphans of Tsavo are legendary—indeed Daphne has written a book about them. As a painter specialising in wildlife subjects, I have made the most of every opportunity to study these animals at close quarters. In fact, if I wanted to walk right underneath Eleanor or jump on her back, I could probably do so — and Eleanor is a full-sized cow elephant. But she is more than that. She is the most remarkable **animal** I have ever been privileged to know. She mothers everybody. She has spent almost all her life with the Sheldricks, from the moment she was found as a tiny orphan. David and Daphne now have five other elephants. All of them were, in similar fashion, discovered as pathetic babies, standing beside the bodies of their dead mothers during one of the severe droughts which are common in Tsavo National Park. And Eleanor has brought them up, aided by Daphne, or the other way round, depending on which way you look at it. There is a remarkable photograph in Daphne's book of David, Daphne and Eleanor all trying to pick up an infant elephant which is too weak to stand. David and Daphne are kneeling on one side, and Eleanor, this wonderful great elephant, is kneeling on the other side trying to lift the baby on to her tusks.

Eleanor has, for a period, 'gone wild'. But she preferred human company and came back to the Sheldricks. They are hoping she became pregnant during that time which would be cause for great rejoicing, and of considerable zoological interest, in the Sheldrick household.

Two of the great 'characters' are Punda, the zebra, and Stroppy, an almost fully grown rhino; it is a most remarkable and unusual thing to see the incredible friendship

I hope your excursion to Lake Tahoe is a resounding success. Indeed I hope it resounds all the way to Zambia in the form of a helicopter for the protection of wildlife.

I have little doubt that your generosity in painting and presenting five pictures will be matched by the competitive and well-known generosity of the members of the Mzuri Safari Club.

At this moment in the long history of the world nothing could be more important than to remind people to take care of this fragile planet of ours and of all the living things which share it with us.

Good luck and congratulations to the lucky ones who end up with your pictures.

Philip

October 1970.

that has been forged between them. In the normal course of events in the wild, the two species would avoid each other. But Punda has such a crush on Stroppy—and, in fact, most other rhinos—that the two are inseparable. Punda, on one occasion, was seen rushing into the bush holding on to the tail of a rhino, thinking it was Stroppy. It wasn't, and after the first few hundred yards the wild rhino grew tired of this treatment. It turned and lashed out with its horn and caught the zebra a gashing blow. Punda hobbled back to the house, looking rather sorry for himself, but he will never learn.

We came in one evening after a drive into the park to witness an astonishing scene. Jimmy, Daphne's beautiful little male kudu, had wandered into the nearby bush and was rubbing noses with a baby waterbuck as if to say 'Come and join us'. The baby waterbuck, unperturbed at our presence, edged gradually nearer to the house, encouraged by Jimmy, while his mother stayed back with the wild herd. In the end, and rightly, he returned to his own kind; but it was a moving and amusing scene to watch.

The animals are free to come and go as they please, with the exception of the rhino and the jumbos which are stockaded at night for their own safety. But it is foreign to Daphne and David's philosophy to think of any form of permanent captivity. Their whole intention is that, when the animals are able to fend for themselves, they will be returned to their natural environment. The impalas are indeed proving this point. A lovely herd of these beautiful little antelopes spends the hours of daylight on the lawn in front of the house, and at night lead a completely natural existence. While with the Sheldricks, one impala has had three young and has brought them up within the environment of the house. But Daphne has a problem with Stroppy: it's hard enough to return a rhino to the wild

anyway, and it is further complicated when there is a zebra in tow.

I have spent many hours of sheer joy and delight watching the orphans having their daily mud-bath. To see five elephants, two rhinos, a zebra and two or three buffalo babies cavorting and playing in the mud is an experience I shall treasure as long as I live.

The shooting of big game will always be a touchy subject. I am often asked to do a painting of an animal that a sportsman has shot. He will send me a photograph, perhaps of his wife with her foot up on the carcase just after the poor creature has dropped in a lifeless heap. It is difficult to be inspired by this sort of photograph. There is no question in my mind that hunting can bring out the worst in people. I once asked a taxidermist in Nairobi what was the most revolting job he was ever commissioned to do. 'Once I had to mount a whole elephant. An American had shot the animal and, quite apart from the astronomical cost of carting the complete carcase all the way out of the bush and down to Nairobi before it began to go high, the whole thing was rather nauseating. Before I shipped it out to San Francisco I had to paint the whole animal pink all over. It was to be mounted alongside his bar in Los Angeles.' But perhaps the elephants got their own back. I have a nice sort of feeling that when they heard that hunter was coming back to Africa they discussed the matter round a waterhole. Then a nice big bull elephant caught him unawares and squashed him into the ground.

Rolf Rohwer was a professional hunter with one of the big safari organisations, until he could stand the killing no longer. So he finally chucked his hand in. But meanwhile he was determined to see that some of the animals he knew particularly well were left to walk around free as long as they could. One American client of his had a licence to shoot a bull elephant and there was a particularly fine one

—old Charlie—living near the base camp. If Rolf knew that the animal was out on the west side of the camp, he would take his client out on the east side, to lessen the chances of their meeting.

Several years ago Rolf asked Avril and me if we would like to come out and have a fortnight's holiday in Zambia as guests of his safari firm. 'I'm sick of all this killing. I hope to God I don't have any clients when you arrive. I'll do my best to keep the fortnight clear. See you in a couple of weeks.'

When we arrived in Zambia, we were met by a crest-fallen Rolf. 'I've got a couple of clients. Did my damndest but couldn't avoid it. They're the most revoltingly spoilt couple I have ever met. Bloody sorry.' Avril and I accepted that it would at least be a welcome rest and we all drove off to the base camp. For those two weeks Avril and I never left it. But there were compensations. It was a glorious set-ting, on the Kafue River, miles from anywhere. The sun shone all day and it was blissfully hot. And we had enter-tainment in good measure to compensate for our lack of mobility.

Rolf would take his clients out all day to get the animals they were licensed to shoot. They would come back at midday, when the sun is hottest, and we would all eat at the table in the tent. If the husband had shot a bigger buf-falo than his wife, she would take her lunch and eat it in her own tent, in a sulk. The following day she might shoot a bigger buffalo than he did, so he behaved in a similar fashion. Apparently, Rolf told us, the wife could not shoot a tin can at 50 yards anyway and, when she pulled the trigger, Rolf would fire at the same split instant. He would kill the buffalo stone dead with a bullet through the brain, while she would probably hit it in the foot. But she would take the trophy back to America with great pride, telling

all her friends about how it had charged and she had shot it.

Rolf took the husband out one morning, and we saw them disappearing down the track in the Land Rover. About six hours later, at midday, we heard loud shuffling noises, round the corner of the tent. 'Give me water, give me water. I'm dying. Give me water.' We could not look at each other for fear of laughing. Rolf had been having trouble with the Land Rover. In came a dishevelled specimen of a man, who collapsed into a deck chair and spent ten minutes taking off one boot. He was groaning and gasping. 'I've walked 25 miles. Give me some whisky.' Rolf told us afterwards that the Land Rover had broken down about $2\frac{1}{2}$ miles off the main road. The wretched man had broken out in a muck sweat at the prospect of having actually to walk through the animal-infested bush, and on his own, too. But Rolf did his best to pacify him. 'Keep quite calm. Just walk down this track, following the Land Rover marks, until you hit the main road $2\frac{1}{2}$ miles down at the end. Then you'll be able to thumb a lift on one of the contractors' lorries. Get off when you reach the river. Then all you have to do is walk up to the base camp, another $2\frac{1}{2}$ miles. Good luck.' So in fact he had only walked 5 miles; his wife, with whom he'd had a row before he went out in the morning, muttered to us: 'The furthest he's ever walked is to the garage.' The husband came up to Avril that evening. 'Do you know, Mrs Shepherd, I've found out things about my wife that I never knew.' We were not sure what comment to make, but you do find out about people in a hunting camp.

The day before our departure, Rolf told his clients, 'It's Sunday today and I'm going to take the Shepherds out.' They made a fuss, but Rolf pointed out that they did not own him on Sundays, as well as all the other days of the week. That last day was perhaps as much of a holiday for

Rolf as it was for us; not one shot was heard. We were all happier with cameras and a sketch book. The following morning Rolf was loading up our baggage to take us to the airstrip. As we were getting into the Land Rover the two Americans were standing nearby. And the wife was overheard saying: 'Now the Shepherds are going, we can get down to some real hunting.' Rolf went white and I like to think that that woman walked for the rest of her safari and took the biggest blisters of her life back home.

The hunting of big game, paradoxically, contributes considerably to wildlife conservation. The required licences to shoot certain species are very expensive and the proceeds go to the Game Department, virtually back to the animals, in theory anyway. Each animal shot must be a male, and for each one killed by hunters under controlled circumstances probably hundreds are taken—regardless of age, sex or species—by poachers. In most cases, animals destroyed illegally die in appallingly cruel conditions.

The poor leopard will always have a price on his head as long as vain women around the world have the misguided idea that they look better in the leopard skin than the leopard does. There are still fashion houses and designers blatantly prepared to exploit the declining numbers of leopards, cheetahs, jaguars and ocelots. It is sickening that the fur trade is still ready to supply the demand, but it is the demand itself that must be stopped. Leopards are caught by enticing them into traps. The normal procedure would be to shoot the animal through the bars, but a bullet hole would spoil the skin and lessen its value to the trade. Eric Balson, who was head of the Game Department in Tanzania, told me of a particularly evil practice carried out by poachers. One of them would catch hold of the leopard by the tail through the bars of the trap and another man would then stick a red-hot iron up its anus, killing the leopard but not damaging the coat.

I brought this story back to England, and the BBC, to their credit, allowed me to tell it over the radio on several different programmes. It caused a storm of comment. I firmly belive that the time has now come when the truth must be brought home in all its gruesome detail to the man in the street. Almost every letter I received after speaking on the radio thanked me for bringing the facts into the open. Otherwise, how the hell is anyone to know what is going on? And it is the eleventh hour for many species. No one really knows how many cheetahs, for instance, are left in Africa—somewhere between 1,000 and 3,000 altogether, perhaps, certainly not sufficient numbers to make fur coats. By publicising the circumstances in which such beautiful animals, now in extreme danger, are killed, perhaps one can alert those film stars and pop singers who get their picture in the papers to think twice about wrapping themselves in coats made from genuine skins, thus setting a trend that others will follow.

I was on a radio programme with a representative from the British Fur Trade Association. He tried to make out that all his members—the shops and retailers that sell fur and fur coats—were beyond reproach. It is strange, then, that in 1974 I saw in the window of a Knightsbridge fur salon—'By Appointment, Furriers to HM The Queen' —two actual leopard skins and one leopard fur coat. A member of the World Wildlife Fund in London, without saying who he was, made a spot check: he rang around five of the leading London stores and asked if they could supply him with a real leopard coat. Four out of the five said they could.

The poachers and illegal hunters of endangered species with a commercial price on their heads can, I believe, be divided into three categories. The person least to blame is the African or Indian living in his primitive bush village.

He has, from time immemorial, gone out to trap or shoot the odd animal for the pot. There is nothing whatever wrong with this, it is part of the pattern of nature.

But it is a very different story when the middle man comes in. He will take advantage of the villager's low living standards and bribe him to go out and do his dirty work for him. £100 will be a lifetime's fortune to the villager. If the middle man offers him this sort of sum, you can't really blame him for going out and killing a leopard. It is the middle man who has to be caught.

But again, that middle man would not be in business if there were no demand for his product. And so the end of the line is the person who buys the ocelot coat or the tiger-skin rug, and the person who buys the ivory as a hedge against inflation, or the powdered-down rhino horn to improve his sexual performance.

Poaching can be, and is, a highly organised and sophisticated business. I have been told many stories of open warfare, lasting several days on end, waged between the park wardens, with their loyal African rangers, and the poaching gangs. The poachers might be armed not only with high-powered rifles but with the odd machine-gun as well. And people are killed, frequently, on both sides. Not a year goes past in East Africa or Zambia without one or more of the rangers being killed by poachers.

One particularly grim story concerned a gang of English poachers known to the authorities in Zambia. With their Land Rovers, they were cunning and clever enough to bypass every road block set up by the police. They would simply drive round it in the bush and come out the other side. The warden who told me this knew these people personally. One of them happened to be in the national park, quite legally, and warden and poacher met.

'If it's the last thing I do in my life, I want to see you bastards behind bars.'

'If you catch us poaching, we'll shoot you dead between the eyes.'

That was a conversation between one Englishman and another and it took place in the 1960s. The poaching is all too often organised and perpetrated by Europeans. Italian businessmen in Lusaka, for instance, go out after dark and disappear into the bush for days. They come back with the boots of their cars full to the brim with skins, ivory and the rest of it. These are the people who must be apprehended. In some countries poachers are shot dead on sight. This treatment is effective if not very British! I believe that the poacher, whether white or black, Italian or English, should get as good as he gives. If he is out to exterminate an endangered species entirely for commercial gain, without so much as a hint of compassion for his fellow living creatures, and is prepared to murder game guards into the bargain, then he deserves to be shot himself. Where this is done, the poaching problem has been cured.

Africa is a big continent, and one cannot generalise on the poaching situation in any one year. In Kenya, tragically, a minimum of 15,000 elephants are poached every year — and that is a lot of elephants: the world price of ivory has probably quadrupled in the past five years and the poor old jumbos are sacrificed to meet this growing demand. Planeloads of ivory take off from Nairobi airport in the early hours to Hong Kong and the Far East, and all the dedicated work of the game wardens is being undermined by some in high places. Unless this corruption is stopped once and for all, the elephant could cease to exist in Kenya within a matter of years.

In Zambia, things are less bad. On many occasions I have been privileged to go out game-viewing with President Kaunda, who is as dedicated to wildlife conservation as I am. And while he remains President, spreading the

message to his people there is some hope for wildlife in his country. But the wildlife must be seen, and quickly, to be of material benefit to the people—otherwise they will clamour for the land to be made over to farming and the wildlife will be doomed. It is now a matter of economics.

Zambia badly needed a helicopter to combat poaching of the lechwe, a swamp-loving antelope living in fairly remote and inaccessible areas; light aeroplanes are no good for this purpose because if a band of poachers is sighted they cannot land. So, through the World Wildlife Fund's British National Appeal, I took on the project of buying and delivering to Zambia a five-seater Bell Jet Ranger. Anything smaller than a five-seater would have been inadequate, for the African rangers using the machine would be at considerable risk if only one or two of them went after a poaching gang. I sent five of my wildlife paintings out to the United States. And the appeal caught on with American wildlife artists, who threw in their pictures. In an hour we raised enough money to buy that beautiful machine. The great day came when the helicopter landed on my garden lawn in Surrey, carrying Eva von Reuber-Staier (Miss World) and myself, and we handed it over to the Zambia High Commissioner with Virginia McKenna watching on. It was then dismantled and I went with it to Lusaka, where it was reassembled. Once again I flew in it, landing at State House, and presented it to President Kaunda.

Four months later, when I flew out to Zambia, I asked the head of the Game Department how things were going. There was a long silence. I thought 'Oh God, they've gone and crashed it,' and pressed for an answer.

'Well, we don't really like to tell you.'

It turned out that the very first poacher to be caught had been an African living in a remote bush village. And such was his intense pride at being the first to be given a

ride in the Bell Jet Ranger all the way from his village to the court in Lusaka that he was beaming all over his face as he sat there, handcuffed to a game guard on either side. It was the adventure of his life and, when he came up before the magistrates, it transpired that all he had killed was one porcupine, for the pot. He was set free and given a Bell Jet Ranger ride all the way back to his village, this time without handcuffs. So conservation has its lighter moments.

But the deterrent effect of this machine in the four years it has been operating has been enormous. There are a number of commercially operated helicopters in Zambia, and a poacher is unaware whether it is 'his' helicopter flying overhead or whether it belongs to one of the mining companies. Stopping the crime before it happens is undoubtedly better than punishing the perpetrator afterwards. And, on at least one marvellous occasion, the Bell Jet Ranger has actually apprehended a European poacher. It landed on the dual carriageway right in front of his Land Rover which was loaded with ivory.

The need for conservation is not, of course, confined to Africa. The tiger, too, is in a desperate situation. Probably no more than 5,000 tigers are left in the wild. In the whole of India, according to the World Wildlife Fund, there are only 1,827 Bengal tigers, the most numerous of the species; there had been 30,000 just after the war. The other sub-species are probably doomed. They are being poisoned, shot and caught in gin traps.

I went to India urgently wanting to see wild tigers. I did not see any because there are so few left to be seen. But I did see just how easy it was to obtain their skins. In the dingy back streets of Calcutta, I went with a friend into a miserable little shop. There, on the shelf, were three tiger skins. The mouths were open, showing tongues made of red plastic. The Indian trader got one of the skins down

off the shelf and put it on the floor. 'Look, you see, no hole in skin. It has been poisoned. Very good.' The implication that the skin was therefore undamaged did not impress me. I could imagine how long it had taken that tiger to die. And what he didn't point out was that the skin was badly cured and would probably fall apart in a few years anyway. I pretended to be a member of the fur trade. 'If I come back in a month can you guarantee me fifty tiger skins?'

'Yes, sir. Just pay me 50,000 rupees deposit and come back in one month.'

We told this to the police, and with a bit of luck this trader might have been floating face downwards in the river shortly afterwards. One of the most offensive stories about poaching to come out of India concerned an Italian who was caught at customs going out of Delhi airport. Not only did he have a large consignment of illicit tiger skins, but he was found to be concealing on his person two live baby clouded leopards, one in his brief case and the other stuffed down his trousers. Both were dead within the hour. There are possibly fewer than 500 clouded leopards left in the wild, thanks to people like this.

In 1973 the World Wildlife Fund launched Operation Tiger—an international effort to save the animal in its eleventh hour. The target was 1 million dollars, about £400,000. The British National Appeal of the World Wildlife Fund was playing a very major part in this scheme, and I had to help the tiger. The best ideas are usually the simplest. While having a bath I suddenly hit on the idea of running off a limited edition of a tiger painting, and donating all the prints, as well as the original picture, to the fund.

We produced an edition of 850 copies of 'Tiger Fire'. The trade took quite a number of copies and sold them at no profit to themselves. All the printing and publishing was done at cost and no one made any money, except the

British government—who took a whopping great slice in VAT. The market value of my limited editions at this time was in the region of £100 a copy; we sold each copy of 'Tiger Fire' for £150. This was an inflated price, but I think justified as it was entirely in aid of the tiger. I multiplied £150 by 850 and came to the almost unbelievable figure of £127,500! A number of people said 'You'll never do it.' I announced the scheme on BBC television and the young lady interviewing me bought one there and then. And the phones started ringing in the studio before the programme had finished. In six weeks we had sold the lot and the £127,500 was in the bag. In just ten days' painting time, more than a quarter of Operation Tiger's international total had been raised. There was an extra incentive for the buyers of the prints, incidentally: one print carried a lucky number and the buyer would receive the original as well.

I invited Prince Bernhard of the Netherlands, the Fund's International President, to come over to London for the ceremony in December 1973. After drawing the lucky number out of a hat, and without any warning, the Prince presented me with his special and personal award, the Order of the Golden Ark—for services to wildlife, in particular to Zambia and to Operation Tiger. It was one of the greatest thrills of my life. And I hadn't given anything away—the picture was going to be painted anyway. The occasion is well remembered in the family, for afterwards Prince Bernhard invited Avril, with Melinda, Mandy, Melanie and Wendy, to dinner with him, and Mandy presented him with a little elephant painting. A few weeks later all four daughters received a charming little Bernhard elephant drawing. He's as mad about elephants as I am.

I went to India again in 1975 to honour an obligation to donate a second painting, this time to Mrs Gandhi, which might raise a further £50,000 to help save the tiger. Hav-

ing failed to see a wild tiger on my first trip, my wildlife friends felt that the challenge to show me one had become as strong as my desire to see one. We drove to the north of Lucknow, almost to the borders of Nepal, to Tiger Haven. Here lives one of those rare crusaders for wildlife—a man who is striving almost alone against seemingly hopeless odds to save a tiny pocket of indigenous forest habitat in which a handful of tigers are fighting what may be their last battle. Arjan Singh and his forest and tigers are surrounded on all sides by humanity, and humanity is winning.

It seemed I might be lucky. There had been two kills the previous night, presumably by separate tigers. So a tiny platform was built in a tree, right over the kill. It was agreed that I would sit up in the platform for three hours and 'Billy' Singh walked me for a mile along the forest track to the tree. As the shadows lengthened and the sun began to go down, so did my spirits. As darkness fell, the forest came alive, and my nerves began to fray at the edges; in fact, I don't think I have ever been more frightened in my life. There was no moon, and there I was completely alone up a tree in the jungle—and tigers climb trees!

I could just make out the dim shape of the kill at the foot of the tree. My heart started bounding every time the jungle stirred—and there are many sounds in the jungle at night. Billy had given me a flashlight. 'You won't hear the tiger come—but you'll know when he's on the kill. He'll get into a frightful temper when he finds that it is tied up with ropes, and he'll try to drag it into the undergrowth. Give him ten minutes to settle and then shine the light at him. But he may be gone in a flash, and then that's all you'll see of him. Good luck.'

With my heart bounding in anticipation, there was all of a sudden a tremendous commotion below the tree and

I knew the tiger had arrived. I gave him a few minutes, during which time he certainly sounded angry, and then scarcely daring to breathe I carefully raised the torch to rest it on my other arm and pressed the button. There, right in the arc of light, was a huge male Bengal tiger. Far from bounding away, he casually looked up with his eyes catching the flashlight like diamonds and then calmly went on eating. The time was 6.50, and I had the button of the torch pressed until 7.30. These were possibly the most exciting forty minutes I shall ever have, but I felt sad. I was seeing a tiger in the wild for the first and probably the last time. Both he and Billy Singh were fighting a losing battle.

The success of 'Tiger Fire' spurred me on to further efforts. I, and many other conservationists throughout the world, have now come to realise that there is very little value in saving tigers, whales, or rare orchids, unless the habitat in which they live is saved. If the habitat goes, then every living creature from insects upwards goes with it. The current international campaign being run by the World Wildlife Fund is to save the tropical rain forests of the world. Whilst statistics are, I believe, one of the quickest ways of sending other people to sleep, it is nevertheless horrifying to learn that the tropical rain forests of the world are being destroyed at the rate of fifty acres a minute. For sheer wanton greed and quick short term commercial gain, the forests are being pillaged, burned, hacked down, and destroyed forever at this appalling rate, and with these acres goes every form of life within.

The tropical rain forests of the world have been called 'an explosion of life'—probably the most perfect complete ecosystem left on earth, pulsating with insect, plant, bird and animal life, each dependent on the other. Once they are destroyed they can never be replaced—and it has taken countless centuries for then to evolve. So, for this cause,

I decided to repeat the formula of 'Tiger Fire' with a painting called 'African Afternoon'. I chose the bongo. This is a very shy, red antelope with white stripes which lives in deep mountain forest. There is a delightful legend the Africans have about the bongo—it is a very fastidious creature and rather than get its beautiful red coat dirty by going to sleep on the ground, it hangs itself up in the trees to go to sleep at night. The formula would be the same as for 'Tiger Fire'. Once again the cynics and the pessimists attacked me. 'You will never do it again—what with inflation and everything else. You cannot expect all those people once again to pay £150 for each print'. Once again I have proved them wrong. 'African Afternoon' has raised somewhere in the region of £75–80,000 for the World Wildlife Fund. As with 'Tiger Fire' I have given the original and one print of the 850 carried a lucky number on it—that person getting the painting itself. Incidentally, the winner of the original painting of 'Tiger Fire', subsequently sold it for £15,000 at Sotheby's—a world record price for a painting of mine. The prints of 'Tiger Fire' have now appreciated to some eight or ten times their original purchase price of £150 in just three years. It seems almost a magic formula now; with one painting, it is apparent that one picture can raise huge sums of money and it is all most exciting.

I am determined to go on to greater things in helping the wildlife of the world. Those of us living on this earth today must ensure that there is at least something left to show our children. Most of the harm has been done in the last seventy-five years; a large number of species are already extinct and many are very near to it. More and more of the world is being eaten up by man's insatiable appetite. Wildlife only has 2 per cent of the world's surface left to itself: it deserves that much. Yet more and more land is being covered in concrete, more and more indigenous

forest is being pillaged. All over the world the wildlife is being pushed further and further back. It is our duty and obligation to rescue something from the wreckage. And if I can play my small part in doing this, I shall be a happy man.

Some years ago, a collection of my African paintings was published under the title *An Artist in Africa*. Nigel Sitwell, of the World Wildlife Fund, wrote the foreword. In it he made a rather nice point: 'David Shepherd has done far more for the wildlife of the world by failing to be a game warden.'

9 PAINTING FOR THE SERVICES

I am decompressed, and fly in a V-bomber—'Your helicopter is waiting, sir'—the Rhine crossing, Naafi coffee and a new Beaver—Arnhem Bridge—Gibraltar, rain and chinstraps—2,000 miles, a Suez taxi-ride and a control tower—100°F and curry and sand for breakfast—to Aden again, among the bullets, into Belfast and the Ardoyne, I meet the 'Provos'—a flight in a Lancaster Bomber and fun at RAF Coningsby—World War II's great scenes

On my return from that momentous trip to Aden, the *Daily Telegraph* had given me one of the finest pieces of publicity I have ever had: they showed five of my paintings over an entire page and coined the phrase: 'A Peace-time War Artist'. This caught on.

Clearly one must have enthusiasm for whatever one paints and I think this enthusiastic approach to the subject is what appeals to the services. They want above all, technical accuracy. Only when they are satisfied on this count will they look at the subject to see if it satisfies them as a painting to hang on the wall. In working to satisfy both these requirements, I have not only made some of my greatest friends, among service personnel, but at the same time had some of my most exciting experiences.

Out of some hundred commissions that I have undertaken for RAF stations and squadrons, army regiments and so on, one for RAF Marham, in Norfolk, presented the greatest challenge. This was to paint an in-flight re-fuelling night sortie in a V-bomber. The need for in-flight refuelling is a simple one: to keep the V-bomber in the air virtually indefinitely. And at the time of painting the picture, the V-bomber was the front-line nuclear deterrent.

The aircraft concerned was a Valiant, the first of the nuclear trio of V-bombers. As with the Vulcan and the Victor, in which I have also flown, the aircraft are only partially pressurised. This means that for comfort and safety it is necessary to wear a pressure suit and oxygen mask. The Air Ministry's stringent medical requirements first had to be met — on the ground, before one took off; people dying in V-bombers can evidently cause problems.

So at Bassingbourne I was shoved into a decompression chamber. This is virtually an aircraft fuselage, the dials and all the rest of it being worked by someone standing outside. The idea is to see if you would survive a partial decompression, or the effects of a window blowing out, in the aircraft when flying about 8 miles up. If the decompression chamber doesn't kill you, then you're OK (as it was cheerfully put to me). The sensation is rather like travelling in a rocket, only downwards instead of upwards. An RAF chap, quite accustomed to the procedure, was sitting opposite. One is supposed to be in contact with the person working the machine outside : what I did not know, and discovered to my horror, was that my intercom was unserviceable.

At a simulated height of some 40,000ft, the chap started working the dials. The effect was horrifying. I felt as though two battering rams were pressing my skull in and that I was going to crack at any moment. I started shouting, but the operator remained unaware of my plight. When Shepherd had almost died, the RAF chap opposite, who was calmly reading *Country Life*, glanced up and saw what was happening: 'For Christ's sake, send him up again — you're killing him!' However, I survived this excruciating treatment and was told I was fit.

As part of the procedure of pre-flight briefing with the crew, an RAF corporal stripped me down to vest and underpants and proceeded to heap on to my unaccustomed

person a dinghy, parachute, oxygen mask, bone dome and pressure suit. All the while he was talking fifteen to the dozen: 'If you have to bale out at 30,000, don't whatever you do press that ring until you press this one, and while you're pulling that one, don't touch that one, etc, etc, etc.' I couldn't understand, and was resigned to the fact that I would freeze to death on the way down in any case. This he confirmed. By this time, I had flown so much with the services and had developed such a rapport with them that I knew their apparently casual attitude was superficial: they are as thorough and painstaking as they can possibly be, not only for their own safety but for that of their guests. I signed the customary 'blood chit', as I always had to before a service flight, agreeing in effect that if they killed me it wasn't their fault.

From Marham the massive V-bomber surged to full power and we were off, an exhilarating sensation it is impossible to describe. I was rigged up on a sort of sling between co-pilot and pilot; this had to suffice as a seat and, apart from all the impedimenta attached to me, I had torch, sketchbook, movie camera, still camera, etc, etc. We took off in daylight and, in the sunset of a summer evening, at 40,000ft, I watched enthralled as the whole procedure of in-flight refuelling was carried out alongside us by two other aircraft, another Valiant and a Vulcan that had taken off from Scampton. Both aircraft, bright salmon pink in the setting sun, were streaming vapour trails in the rarefied air. All was complete silence.

The British pattern of flight refuelling is the simplest and most efficient. The tanker aircraft lets out a drogue on the end of a hose run off from a drum in the bomb-bay. The drogue floats out into space and it is then the job of the receiving aircraft to nudge up underneath the tanker so that the probe on the end of its nose goes into the drogue. On contact, it releases a valve and the fuel begins

to flow. After the Vulcan was refuelled, our own Valiant became the receiver, the whole procedure going on in the dark. The tanker was floodlit underneath and the drogue floated out towards us with little pinprick lights around the edge. It was like an aerial ballet. Throughout the ten minutes of taking on a full fuel-load, the RAF flight crew appeared casual as usual, but in fact, for obvious reasons, the utmost concentration was necessary. Our pilot, having closed in to within 40ft of the tail of the tanker, had to keep to exactly the same speed so as to retain contact in the drogue itself. You break contact if you fall back, and if you apply too much power you push the drogue back on to the drum in the tanker.

The flight lasted some five hours and again the strain, being cramped up on a sling with all my equipment, combined with the excitement of the whole experience, proved almost too much for me — I suffered the acutest nausea and very nearly passed out on the way down. But it was well worth every second of it.

When it came to doing the painting, I not only had to portray the tanker above us, seen through the windscreen of the Valiant in the dark, but also to take in virtually the entire instrument panel of the V-bomber. This meant checking that all the needles on the countless dials were in the right position for 35,000ft at 245 knots. I spent at least a couple of hours sitting in a Valiant on the ground, while a group captain went from one instrument to another telling me where all the needles should be. When the painting was subsequently unveiled at Marham, there was no thought amongst the gathering as to whether it was a nice painting until every member of the officers' mess was satisfied the technical details were correct. 'He's got the revs on the port outer a little low'—the slightly pompous very junior officer was promptly sat on by the others: the

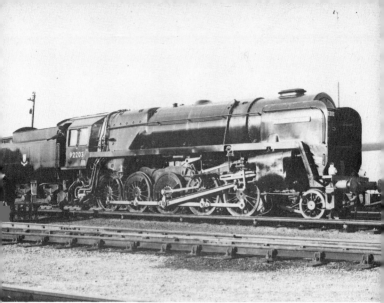

Above: No. 92203 Black Prince at Eastleigh Locomotive Depot open day, 1972, with David Shepherd in the cab (*Norman E. Preedy*)

Below: Zambezi Sawmills Railway motive power

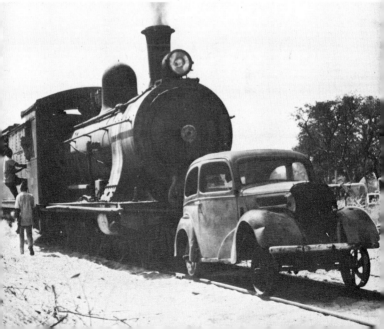

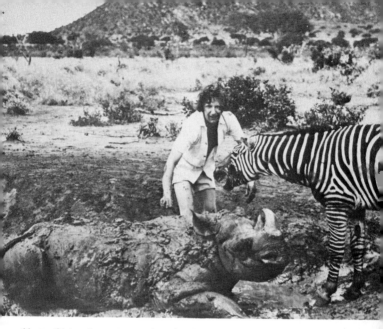

Above: Giving Stroppy a mud-pack, with Punda interfering as usual

Below: Avril with Pushmi

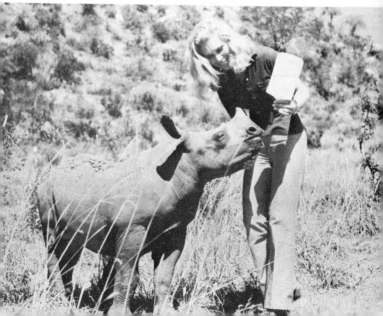

Above: Prince Bernhard and 'Tiger Fire' at the London Party where he awarded me his order of the Golden Ark

Right: At Jimmy Chipperfield's home

Below: The Family, with Esme, at Longleat

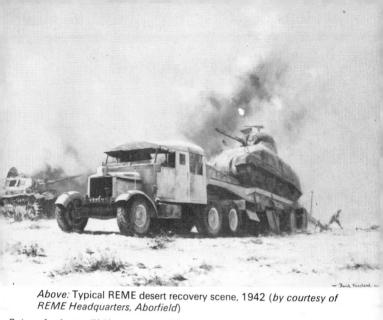

Above: Typical REME desert recovery scene, 1942 (*by courtesy of REME Headquarters, Aborfield*)

Below: An Auster IX (*by courtesy of Army Air Corps Centre, Middle Wallop*)

Above: Painting 'Rambo' at Cadgewith

Below: Final touches before 'Christ' is moved to Bordon garrison church

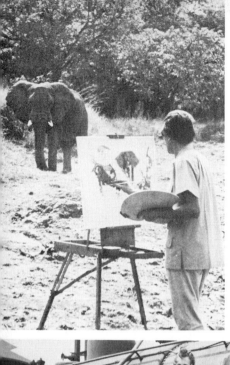

Left: Painting jumbos in the Luangwa Valley

Below: The BBC TV production team at Germiston sheds, Johannesburg

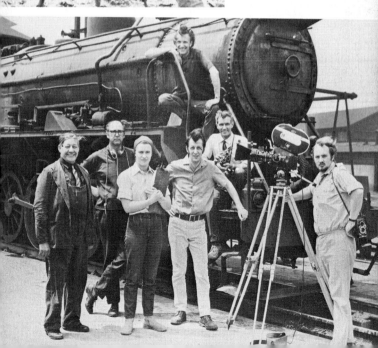

Dated 7 of 1876
(both with broken platforms) — one roof burned out after
fire also damaged.

Valiant we had flown in *was* slightly low in revs on the port outer!

Commissions began to arrive from the services all over the world. And if one is asked to paint the jungles of Malaya or the deserts of Arabia, one has to see them; and the services have never failed me yet. My free flights with RAF Transport Command did not, of course, cost the taxpayer anything: the aircraft were flying out anyway.

The Army Air Corps at Middle Wallop, in Hampshire, were among my earliest clients. I have flown in, and painted, almost every type of aircraft they use. They phoned one day, when they knew the final painting was ready for delivery: 'You don't want to drive all the way over, do you?' I knew what was coming, and had the map reference for our garden ready. So a training exercise ensued and an army Scout helicopter duly landed on my lawn, picked up me and the painting, and a matter of twenty minutes or so later we arrived at Middle Wallop for lunch. It was a VIP occasion and out came the mess silver. A couple of generals and an admiral, the other guests, had been driven down from London in their staff cars. After lunch, over brandy and cigars in the anteroom, my ego was happily inflated when a junior officer, passing the two generals and the admiral, announced to me in front of them: 'Your helicopter is waiting, sir.' The aforesaid gentlemen, who were super chaps, had to go back to London by road.

Another commission which occasioned VIP treatment was a painting of the Rhine crossing — the historic airborne operation that was part of the final drive to Berlin in the closing stages of World II. The 5ft picture was commissioned by the 13th/14th Parachute Regiment, TA. As with all such assignments I believe that one must re-live the actual event, as far as one can. The army laid on a Beaver aircraft. The plan was to fly up and down the

original dropping zone at precisely the same height, same time of day and same time of the year as the Dakotas had done when they dropped the men of the airborne forces.

The colonel and myself drove down to Manston, in Kent, where we were slightly taken aback by the pilot, who brought the Beaver in from Middle Wallop, announcing that the thing had only $1\frac{1}{2}$ hours' spare flying time before it was due to go in for a major overhaul and be taken to pieces. We thought this was a bit odd; it is easy enough to lose $1\frac{1}{2}$ hours through one sort of delay or another. Sure enough, as a result of landing to clear customs in France and other delays, by the time we flew in to RAF Wildenwrath, Germany, the pilot announced we could go no further. So we were stuck, with a rather sick aeroplane. In the airmen's mess, over rather nasty coffee in plastic cups from a slot machine, we discussed what we should do. I suggested that we telephone 'Shan' Hackett — General Sir John Hackett, GCB, CBE, DSO, who was commanding Britain's NATO forces in Europe. The change in atmosphere was instantaneous. The colonel and myself were picked up almost bodily and taken into the VIP lounge. The bar was opened and we were offered every sort of hospitality.

I had met Shan Hackett through a painting I had done of Arnhem; he had said then, 'If you ever need any help, David, do let me know' — and I have found in life that if people say this sort of thing, they expect you to take them up on it. In a matter of minutes I was through to him, explaining that we had a useless Beaver sitting on the tarmac outside and that if I was to do the painting, I must see the dropping zone. Within the hour a new Beaver had landed at Wildenwrath and it was put at our disposal! As we walked out to the aircraft, the colonel said, 'Christ Almighty, even I can't bloody well get away with that! And you're not even in the army.'

As with all other pictures of this nature, an enormous amount of research had to be undertaken, necessitating many visits to the Imperial War Museum, and meeting people who actually took part in the operation. But one has to be very careful. Thirty years is a long time and memories begin to fade. General Darling, who had dropped with the airborne forces over the Rhine, generously lent me the actual map he had in his pocket at the time. As I began to do more research, I realised, surprised, that the line of flight drawn on this historic document was in fact inaccurate. The day of the picture's unveiling at a VIP luncheon at Aldershot duly arrived. It hung on the wall under a curtain and General Darling himself was to perform the honours. The curtains parted and, within seconds, he turned round and politely said, 'I'm sorry to mention it, David, but are you sure you have the line of flight correct?'

'I'm awfully sorry, but your map is wrong.'

Realising that I had obviously done a great deal of research on this picture, he graciously accepted that I was, in fact, correct. None of the senior officers I have met in the services would presume to be infallible in such a situation.

I was asked to paint a picture of Winston Churchill and King George VI watching the bombers take off on the first raid from RAF Marham, in Norfolk. The Wellingtons had set out at dusk one winter evening. Although we managed to get together several people who actually witnessed the event, half of them insisted there was snow on the ground and the others were sure there was not. Memories, even of historic events, fade quickly. But the artist has to try to please everybody.

Another challenge was to paint the battle of Arnhem; I have painted two large and detailed canvases of this tragic operation. Shan Hackett, who was there, told me he reckoned I knew more about the operation than he did. This is

not as stupid as it sounds. When one was actually taking part in such momentous events, one did not think about recording them for posterity. One just got on and did the job.

The annual pilgrimage still takes place to Arnhem. I have attended two of these and, to an outsider, it is amazing how much emotion is stirred up among the inhabitants on these occasions. The Dutch are warm-hearted people and compete to offer hospitality to their British visitors. The whole town has left a very vivid impression on me. Going there, with officers who actually took part in the operation, was most evocative and, after the tremendous amount of research I have undertaken, I almost feel as if I had been at the bridgehead myself in 1944.

The first painting I was commissioned to do was of the bridge itself. In it I portrayed the very moment of 5pm on the second day. The 2nd Battalion of the Parachute Regiment were grimly defending the ramparts of the bridge and there was house-to-house fighting across and underneath the approaches. Indeed, the fighting was so close at hand that at times it was hard to tell whether the Germans or the British were in any particular house near the bridge. At that precise moment an RAF Mosquito flew over the bridge, just as a German column of trucks and tanks was crossing it. The Germans didn't see the men of the 2nd Battalion, who were dug in on the rampart of the bridge, and the whole column was 'brewed up'. We enlarged the photograph taken by the Mosquito and an amazing amount of detail came to life that had perhaps not previously been deciphered. For example, what had been just a blur turned out in the enlargement to be a knocked-out German truck below the bridge, and we even found through the magnifying glass that the driver was hanging dead from his cab. So all this detail went into the picture, driver and all. General Frost, who commanded the 2nd Battalion at the time,

wanted almost to stand behind me while I painted the picture, such was his kindly but strict demand for complete historical accuracy. And I gave it to him. But I think the only thing that he allowed me to put where I liked was the smoke! And there was plenty of that.

The second painting of Arnhem that I undertook was 'The Cauldron'. This was the name given to the bloody battle that took place round the Hartestein Hotel and at the crossroads in the village of Oosterbeck, just a few miles from Arnhem. The hotel was the final perimeter into which the British were compressed in the very last stages of the battle. British and Germans were shooting at each other through a dressing-station which had been set up in a hotel on the corner, and all hell was let loose. Flying a white flag, a German half-track came up the road and the senior German officer met Shan Hackett. It was agreed that in an interval of twenty minutes the wounded would be taken out to safety, and then the fighting would restart. It was a great honour for me to record this scene, surely one of the last great moments of chivalry in modern warfare.

Again, the research proved not only fruitful, but fascinating. Two corners of the crossroads had been completely rebuilt since the war. But as I sought to discover what they looked like at the time, I was passed from one Dutch civilian to another until finally we met a lady who quite casually announced that she thought she had some old photographs up in the attic. It turned out that these had been taken by her husband while the bloody fighting was actually going on—he had evidently walked out into the middle of the battle and photographed it—and they showed all the details I needed. We discovered what the tram-cable supports looked like, and these have long since disappeared; an old Dutch car was in the trees at the corner, and this went into the picture as well.

The Hartestein Hotel building is the original one, since

repaired. And the people drinking their coffee in the gardens can have had little thought for the dramatic acts played out on those very lawns some thirty years before. But had they looked above their eye-level, as I did, they would have seen that every beech tree in the garden was dead and shattered at its top. This was at first glance the only evidence of the blasting these trees suffered from the terrific bombardment; but if one looked closer, the trunks of all the trees were spattered with shellburst. One of the officers who was with me pointed out one particular tree: 'That's where a chum of mine was shot dead.' The bullet marks were still in the bark, but that much higher off the ground, as the tree had grown.

Only a few years ago, up on the dropping zone for the gliders, near the town of Arnhem, one could still see the burn-marks in the heather where the Germans had set fire to the gliders after the operation. If one is an artist with enthusiasm for a subject, one develops just that little extra perception to notice small details like this which are so vital. Arnhem is a tremendously evocative place, even after all these years.

Painting a picture of Lingèvres, in France, again required memories to be re-lived in visiting the actual location. This small but historic tank engagement followed up the D-Day landings and the initial push into France. Armed with photographs from the Imperial War Museum Photo Reference Library—a mine of information that has always been for me—I went to the exact spot with some of the officers who actually took part. We stood exactly where a particular photograph was taken just after the battle and saw the gap in the hedge where a German Tiger tank had been pushed aside out of the way, all those years before. The original telephone poles still had shrapnel and shellblast marks; and all the while the 1974 traffic dashed by, unaware.

In painting action pictures of World War II, I am much happier when the emphasis is on machines rather than men. But if one paints for the services it is inevitable that eventually one will be asked to record a ceremonial parade. This, frankly, is not a subject for which I have a great enthusiasm, but to the regiment concerned the presentation of colours by royalty is a great and memorable occasion. I was commissioned to paint Lord Harding presenting colours to the Somerset and Cornwall Light Infantry in Gibraltar. The ideal way to study such an event for a painting is to go to the final dress rehearsal. One can then take one's time to pick the best position from which the photographs or sketches must be made. One has to work quickly because the actual ceremony is over in a matter of seconds. Unfortunately, on this occasion, I was not able to get to the dress rehearsal in time. I arrived in Gibraltar the day before the actual presentation was to take place. I was told that I could have special permission to walk out on to the square right into the middle of the ceremony at the given signal. And I was to choose my best vantage point by discussing the layout of the parade ground with those taking part.

The day dawned, but instead of lovely warm Mediterranean weather the rain was coming down in torrents, with a gale howling right off the sea. The parade started and I was standing in the wings. I watched with horror as the band marched backwards and forwards across the whitewashed spot I had marked the previous evening to indicate the point to which I would dash at the given signal: the mark was rapidly disappearing. The moment arrived and I ran out with my camera. To my horror, everybody was out of their positions: where I should have had a clear view of Lord Harding bending over and presenting the colours, all I could see were the massive backviews of three large army chaplains, an impenetrable barrier to my line

of sight. I panicked. Dashing hither and thither, I fired off photograph after photograph, not really knowing what I was pointing at. Lord Harding could hardly be asked to go through this moving and solemn moment in the regiment's history again!

Back in England, the little yellow box of film returned from Kodak, and I knew that disaster had struck—when transparencies are successful they are sent back in a little flat box, but when they are not they are sent back in a little square box. Sure enough, a considerable footage of absolutely blank black film unrolled; not one picture had come out.

I had no material to work from except memory. In desperation I went up to Shrewsbury, to the regimental depot of the Somerset and Cornwall Light Infantry. In the kitchens of the Naafi, we found a tiny little lance-corporal about 5ft 5in high, peeling spuds, hauled him out and asked him to play the part of Lord Harding. He did not seem unduly perturbed; indeed he entered into the spirit of the thing most wonderfully. We tied an army blanket to a broomstick and got him to present the 'colours' to another lance-corporal, in filthy overalls, who had been working on an army lorry. I did the whole painting with the invaluable help of these two gentlemen, and it was their finest hour!

But I came up against another dilemma, as so often happens when painting pictures for the services. The artist must try to supply complete historical accuracy, but he must also bring in enough artistic licence to make it a painting: where does one draw the line? This Gibraltar painting was the perfect case in point. Because it was a windy day and pouring with rain, the men, in No 1 mess dress, all had their chinstraps down to stop their hats blowing into the Mediterranean. But this, I was told, was very 'unsmart'. So a hot debate ensued among the mem-

bers of the mess committee. 'Do we want the chinstraps up or down?' The majority wanted them down because that was how they had been on the day, but the others said, 'No. In future years, we shall forget it was windy, we'd rather the artist took a bit of licence and painted them up, where they should be, over the peak of the cap—because, old boy, it's smarter like that.'

The majority won the day, and down went the chinstraps on all the men lined up in the background. But I had a sinking feeling that, after living with the picture for six months, they would come back to me having changed their minds. They did. They had decided it looked sloppy with the chinstraps down and asked me to paint them out. There is a certain problem when one overpaints a dark patch with a lighter colour. After a time the dark paint underneath is likely to begin to show through. I have not seen this painting for years but have a ghastly feeling that all the men now lined up in their best No 1 dress on this great day look as if they need a shave!

One frequently has to go to an enormous amount of trouble, which in retrospect seems rather pointless, to get the background to certain paintings. I was commissioned to paint the 1956 Suez landings at a place called El Gamil, a few miles west along the coast from Port Said. I was given a lift as far as Cyprus with the army, then participating in an exercise on the island, which meant that I saw a bit of Cyprus and had some fun. But then I had to make my own way, by an obscure civil airline, from Nicosia to Cairo, get a train all the way to Port Said, and follow this by a ride in an ancient taxi to El Gamil itself. All I could see there was a control tower and a couple of palm trees which had grown about 12 inches higher since the Suez operation. Otherwise there was nothing except flat sand. And the cost of transport came nearly to the price I was paid for the painting! However, it was all good experience

and I saw a bit more of the world—even though it was nearly all sand.

I found myself back in Aden again just before the British pulled out in 1967. And it was a crazy situation towards the end. Bullets were whizzing around between the two Arab Nationalist factions and, as always, the poor old British army was in the middle trying to keep the peace. A senior general had been refused permission to go there because, at these closing stages, things were pretty bad. The fact that I was permitted to go must have meant simply that I was more expendable than the general; but I still felt terribly important. I was driven around in an armoured Scout car and told to keep my head down, and was escorted to Check-point Charlie, a heavily guarded, sand-bagged and fortified house overlooking a wide area of the trouble-scarred town. This was the subject I had to paint.

Poor Mike Walsh, the CO of the 1st Parachute Battalion, for whom I was doing the painting, must have been driven demented. He was responsible for my safety and was not anxious to have to inform Avril that my head had been blown off 'in action'. I apparently did just about everything to achieve this end. My professionalism tends to get the better of me, and I was determined to get the best view possible of what had to be painted; and this naturally meant standing on top of the sandbagged emplacement in full view of everybody. 'I wish to God that bloody artist would get his bloody head down. He's going to get it blown off.' However, I returned home safely.

The 1st Battalion, The Green Howards, telephoned me one day and asked me if I would be prepared to do a painting to commemorate one of their many tours in Northern Ireland. My first reaction was one of extreme reluctance—the situation to my mind was such that I could raise little enthusiasm. However, on giving it a little thought and

with a bit of persuasion from the Regiment, I decided to take the picture on, particularly as they emphasised that they did not want a bloody action picture. They wanted me to portray a routine, and very often boring, moment in the life of an ordinary soldier in that unhappy country.

Firmly believing, as always, that I must 'live' the subject, whatever it may be, to get the atmosphere, I therefore flew to Belfast and spent a memorable week with The Green Howards. I was based in Armagh and one of my first experiences was the fly down to Crossmaglen in a helicopter with the Army Air Corps. This village in one of the most beautiful parts of Northern Ireland is, apparently, almost entirely Republican, with considerable sympathy for the IRA cause. The British army strength in the town consisted of one officer and some twenty or thirty men, and they were 'imprisoned' in a house which used to be the Police Station. I have never seen anything quite like it —the entire building from one side, over the roof and down the other, was cocooned in a steel mesh safety curtain, to prevent the IRA lobbing mortar bombs into the house. We landed on a patch of ground next to the house and leapt out of the helicopter and ran in through a small hole in the chainlink and we were inside. The officer who showed me around was killed a week later by a booby trap bomb.

After some discussion with the Regiment, it was decided that I should paint the Ardoyne. We drove up to Belfast. The 1st Battalion, The Parachute Regiment were in command at that time, and having painted many pictures for them in the trouble spots of the world, they decided that if I was going to wander into the Ardoyne on my own with my camera, they should give me moral and physical support, with a foot patrol and an armoured personnel carrier. I believe they were remembering my last visit to Aden in 1967. As things turned out we realised afterwards that this

back-up was the mistake we made. I wandered into the Ardoyne and within minutes I was surrounded by hate. Never having been in a position like this before I was completely taken aback. Fifteen women gathered around me at once and started shaking their fists, spitting at me, and calling me every filthy abuse known to them 'Go home you filthy British bastard, murdering British pig', and worse. My first reaction, possibly unwise, was one of extreme anger. I was there to do a job, as an artist, and I was not going to be talked to like that by anybody. When questioning their behaviour it turned out that they all assumed that I was the hated 'special branch'. No matter what I said nothing could change their minds. 'If you were an artist, why would you have the bloody Parachute Regiment backing you up?' I suppose from their point of view it seemed logical.

There was no turning back. I was determined to get my pictures. I wandered down further into the ghettos of the Ardoyne. Here was all the squalor, the devastation, and the misery which I had heard and read about and seen pictures of so often; but it is always worse when one sees it first-hand. Here were the narrow and dark alleyways, their ends painted white to make clearer targets for the British soldiers. Here were the streets of gutted houses; other streets were divided down the middle along their entire lengths with tall chainlink fences to keep Catholic and Protestant apart. Also, here were the pitiful contrasts. Walking through all this desolation and hate, I was invited into no less than three different homes for a cup of tea by elderly ladies standing on their front doorsteps. Was it a trick? No, I was told afterwards—they just wanted to hang on to some shred of sanity and talk to a strange face. I was asked to admire some beautiful roses blooming in a pocket handkerchief of a garden, itself surrounded by desolation.

I took my pictures and once again became surrounded by a group of people jeering and abusing me. At this stage the women were joined by three thugs dressed in filthy jeans—I took them to be yobos. They told me to get out —it was their territory. I refused. (In retrospect, I remember making some singularly inept comment such as 'It's a free country'!) They began to get threatening, and it was obviously at this stage that the sergeant and his men in the armoured personnel carrier, a few yards behind, decided that I was coming to the point when rescue might be necessary—otherwise they could see me leaving Northern Ireland flat on my back! They descended from the vehicle and came up and sorted out the three thugs. Apparently satisfied, they wandered up the road and round the corner. 'Do you realise who you were talking to?' asked the sergeant. 'No,' I said, 'they looked like yobos'. 'The one you were talking to,' said the sergeant, 'as far as we know, is the leader of the Provos in the Ardoyne, and the one on his right is his second lieutenant. We know the other one has shot at least three British soldiers.'

Half an hour later, having a cup of tea in the Parachute Regiment mess, I admit to feeling not a little queazy. However, it was all worth it. It had given me an insight into what life is like in Northern Ireland for the British Army, and had increased my already unbounded admiration for the troops a thousandfold. I honestly believe no other army in the world would do such a job, and do it so willingly. I obtained all the material I needed, and the painting has been a great success. When 'Ardoyne Patrol' was unveiled to the Green Howards in Berlin, the general comment was, 'You can almost smell it!' There was the squalor, and all the obscene graffiti on the walls—and yet somehow I had got some pathos into the painting too. Perhaps there is some hope?

Painting for the services I have been down in a sub-

141

marine, sailed in frigates and cruisers, and flown all over the place in helicopters. In Malaya I had some wonderfully exciting trips in a little Auster IX, flying into long-over-grown jungle airstrips where we seemed to take our lives in our hands as we flew into the trees. I have spent three fascinating weeks deep in the Libyan Desert with the Special Air Service. They were doing desert navigation exercises and it was a great thrill to live and work with them, and see the tough life they lead. My only regret was that they could not, or would not, vary their menu. Despite having loads of tinned food of infinite variety in the Land Rovers, it seems that the British Army, when on exercise, even in the hottest parts of the world, has an insatiable desire for curry and little else. For breakfast, lunch and tea out it came, mixed in mess tins cleaned out with sand. It burnt your guts—I've never had curry since.

As a result of knowing the CO of the 4th Royal Tanks, Avril and I spent an unforgettable and exciting morning driving a massive Conqueror tank over the army ranges in Dorset. (Some of the other things we did should perhaps not be mentioned in case anyone should get into trouble!) There were also hilarious times with the Territorial Army in Germany. We went across the Channel with the Navy, being violently seasick all the way, and then did a tour of the Dusseldorf nightclubs with the Territorials. I have in fact forgotten just about everything else about that particular occasion: but I do believe it was all to do a painting.

Up at Scampton, in Lincolnshire, the airfield from which 617 Squadron took off on its memorable dambusting raid, hangs a painting of mine called 'F did not return'. In the foreground is a Lancaster, one engine on fire and half its tail shot away, going down slowly into the cloud. She is obviously not going to make it back to England. This painting tells an evocative story and is the sort of work I would do for sheer enjoyment.

The Royal Air Force Benevolent Fund approached me recently to ask if I would do a similar scheme to that for saving the tiger, to help the Fund. How could I refuse? Without the help of the Royal Air Force I might never have returned to Kenya and started painting elephants. For many years I have been longing for an excuse once again to paint a Lancaster. Here was my chance. I decided that the picture would be entitled 'Winter of '43, somewhere in England'. I did not want to paint Lancasters flying out on a raid—all the other artists do it this way. I wanted to paint a picture which would evoke all the memories of so many Bomber Command ground and air crews in England in World War II. Here would be all the ingredients—Lancasters at far-flung dispersals, with all the ground equipment from bomb trolleys to crew bus, the ground crews servicing an engine in the long shadows of an English autumn evening, bicycles, the mud, the bare elm trees, and so much more. I would paint the moment when the Captain would arrive in his staff car at dispersal, a couple of hours before dark and take off: 'Revs on port outer were a bit low over Essen last night—get them right, Charlie, it's a big one tonight"'.

The Royal Air Force Battle of Britain Memorial Flight maintains, in fine flying condition, just one Lancaster, PA 474 City of Lincoln. The Imperial War Museum has countless photographs of just such a scene taken at the time, but these were not for me. Using someone else's material would afford me little inspiration. With a real Lancaster why should we not recreate the scene? There are many people in England who have restored, with loving care, World War II vehicles of all types. Just as I have purchased steam locomotives for posterity, so has a vicar saved a 1940 Hillman Staff car; we found a farmer who could produce a Royal Air Force tractor which would have been used for towing bomb trolleys; another owns a

Bedford 3-ton wagon of the period; somebody else produced a genuine Royal Air Force Battle of Britain Biggin Hill motor bike, and the list was endless.

At the appointed time and with the blessing and help of the authorities, we all descended on RAF Coningsby, a Phantom Jet station. This also happens to be the home of the Memorial Flight, and with 'City of Lincoln' as the dominant centre-piece, the whole period atmosphere was recreated with the attendant vehicles—and their owners feeling proud beyond belief! I took my sketches and the painting has been an enormous success, raising a large amount of money for the Royal Air Force Benevolent Fund.

There was one favour which I asked—and which was duly granted. I had two half-hour flights, sitting in the mid-upper turret of 'City of Lincoln', to Humberside and back. It was highly evocative dipping our wings over Lincoln Cathedral, that great landmark which must have meant so much to countless bomber crews returning from Germany. On the return journey, one of the Royal Air Force Memorial Flight Spitfires flew just a few feet below and alongside me. Surely it is worth donating a few days of one's painting life to a charity and to be rewarded with such thrills!

The City of London now owns a painting I did way back in 1954 of a Spitfire symbolically and triumphantly flying over the smoking ruins of the City after the great fire-raid on 29 December 1940. Yet another subject I painted for myself and subsequently sold was a crashed Heinkel III, shot down in the Battle of Britain. During those momentous days, life had to go on. And so I portrayed a couple of plough horses, carrying on with their work, moving past the crashed aircraft. In the background, against a cool grey sky, is a row of bare elm trees, with rooks' nests in the top of them. The landscape of an Eng-

lish winter is no less beautiful because of the 'litter of war'.

In so many officers' messes I have seen the inevitable paintings of Balaclava, the Charge of the Light Brigade and other dramatised heroics of the past. But how rarely one sees pictures to commemorate the great scenes of World War II: they should be recorded while there are still those who can remember. A few of us, who record war and action on canvas, have done our best to fill that gap; I am proud that I have played a small part in doing so, with over 100 paintings hanging in messes all round the world. And what fun it has been.

10 A FEW PORTRAITS

*I paint Christ; 'Jesus' comes to tea — Sheikh Zaid of Abu Dhabi —
I cut his head off, and other desert adventures — The Queen
Mother, and happy days at Clarence House — The President of
Zambia, a Woolworth's chair and hippo interruptions — and
other portraits*

I have painted only a handful of portraits. But I have
been lucky enough to be very selective and most of my
sitters have been pretty important people, starting with
Christ. The actual business of doing most of the portraits
has been liberally sprinkled with moments of hilarity,
nightmare and general chaos. However, as the paintings
were happily received by the recipients, the conditions
under which they were produced do not seem to have
made any difference: indeed, working under extreme
pressure may have led me to paint that much better, as is
often the case.

The painting of Christ must be for me the most memor-
able one I am ever likely to do. It was in 1964, as I men-
tioned earlier, that I was asked to paint a reredos for the
quaint little tin church serving the garrison at Bordon, in
Hampshire. The army church authorities had decided that
St George's church should have some sort of memorial for
all the regiments that had served there, and this would
eventually go into the new church to be built under the
army building programme. I don't know, incidentally,
what priority churches have in army rebuilding schemes,
but clearly not a very high one; the original church was
destined, I gather, to be rebuilt many years ago, but it is
still standing. It is a dear little place and I, for one, dread

the prospect of it being knocked down and replaced by a concrete monstrosity.

I had been called to a meeting of army chaplains and was so overwhelmed at the honour of being asked to paint Christ that I believe I said 'Yes' in a sort of daze. It did not occur to me to say no. But I remember as vividly as though it were yesterday pulling in to a layby on the way home and thinking to myself as I switched off the engine, 'My godfathers, what on earth have I done?' I had never painted portraits in my life, except a few spotty little boys and dumb débutantes while I was training with Robin Goodwin. The new responsibility was all the more frightening because the money was to be raised by public subscription. People were to be asked in the national press to support the 'Bordon Memorial Reredos Appeal'. I broke out in a cold sweat. I could not go back to the army and say I'd changed my mind. And when I really began to think down to the roots of the problem, it terrified me.

Where and how was I going to find a model? You can't just sit down and paint Christ without one; at least I couldn't, and even Rubens probably didn't. I tried to kid myself that if I went to the army and asked them to supply the model for Christ, they would provide one out of the stores. I had a mental picture of myself stopping everybody with a beard—there weren't so many about in 1964 —and having a look at them, then having to say 'No, I'm sorry, chum, you're no good', and then going on to the next one. You can't just go up to any old beard in the street and ask if it will pose for a portrait of Christ. The person has got to have character, a strong face and many other qualities. It all seems a bit hilarious now, but the problem of a model was solved as if by a miracle— and lots of those happened with this painting. I was living at Frensham at the time and the local paper, the *Farnham Herald*, carried a lead feature on this exciting commission

going to a local artist. The article must have given the impression that David Shepherd was about to have a nervous breakdown over finding a model—which I was. They more or less said, 'If anybody thinks he looks like Christ, will he ring this newspaper office?' This is exactly what happened.

'I'm known as Jesus by me mates—do you think I'll do for that artist who you wrote about?' Apparently over in some remote area of Hampshire, presumably working for the Forestry Commission, a group of bachelors lived in caravans. One of them had grown his hair long and acquired the nickname of 'Jesus'. It turned out he had been pushed into ringing the newspaper office, I suspect as a joke. Anyway, the *Farnham Herald* said, 'We don't know what you look like, but on David Shepherd's behalf we'll come up and take a look at you and if we think you're good enough, we'll all go along to his studio.'

They brought him along, and it was just like Christ walking into my studio in winkle picker shoes. It is one of the most incredible things that has ever happened to me. I say I am not particularly religious, but nor could I be an atheist—I could not possibly be one after this painting. I have painted getting on for 1,600 pictures, but none of them has ever quite come off the brush like this one. And the model was the beginning of the success story.

David Winter had never been in an artist's studio before. But he was a very sincere man and he agreed to sit for a small fee. Although I had found a model, however, I was still dumbstruck at the sheer responsibility of it all, and kept putting the picture off. People were all the while sending money to the appeal, with little notes saying, 'This is in honour of my husband who was at Bordon and who was killed in the war. I want you to wish the artist the best of luck.' Or, 'My son served in France and was killed. When I go to St George's and see the painting, I shall be

reminded of him. Good luck to David Shepherd.' The responsibility made me curl up with anguish. Finally, after waiting four years, the War Office rang me up. 'The consecration service is on 26 July. We've got the Chaplain General to the Queen. You've got to damn well do it by then, otherwise you will be shot at dawn'—or something like that.

I now had to go and find David Winter. I hadn't seen him for four years and, for all I knew, he might have emigrated or even cut his hair off. On a dark, wet evening, I set off into the depths of Hampshire and finally found myself driving up a muddy lane somewhere between Winchester and Alton. The rain was streaming down, and coming in the opposite direction was a tractor. I pulled in to let it pass and I asked the driver, 'Do you know where David Winter lives?'

'Oh, Christ, you mean Jesus. He's on the end there.' Sitting with his legs dangling off the back of the trailer was an apparition covered in mud from head to foot and drenched by the rain; and his hair was full of branches. I thought to myself, 'My godfathers, I'm never going to get him clean in time!'

'I'm still waiting. I thought you'd forgotten.'

There were a million other problems to solve before I could start. I had been asked to do the job because the army saw in me someone who would, they hoped, give them a factual, down-to-earth painting. 'We don't want any fat cherubs floating about all over the place.' (The army has a basic way of putting things.) 'Nor do we want a lot of squares and triangles.' I knew what they wanted and I was determined to give it to them. They said they wanted a portrayal of Christ that 'would bring the men into church'.

My religious knowledge was more or less limited to having seen the Cinemascope epic, *The Robe*. Presumably

149

this film bears little resemblance to fact, but it was good box-office and obviously made some lasting impression on me. I remembered that whoever it was who played Christ was dressed in a very simple cotton garment tied at the waist with a cord and carried over his shoulder the 'robe' of the film's title. This I remember was of a rough, home-spun yarn in a lovely rust colour. That was what I wanted and must have. I had heard of Bermans, the big theatrical costumiers, in London: if you wanted outfits for 15 Gestapo officers, 100 German storm troopers, or six dozen Hebrew slaves, all you did was go to Bermans and you could usually get the kit over the counter. I didn't think there would be any problem. But things didn't work out like that. 'All the Christ costumes are out' (that seemed strange as it was nowhere near Christmas). 'We can offer you this one—I'm afraid it's all we have.' It was Peter O'Toole's costume for *Lawrence of Arabia*, complete with bullet holes and bloodstains. But I was not asking for Lawrence of Arabia—I was asking for Christ. I walked out in a huff. That evening at home, Avril said, 'For God's sake, let me make it and have done with it.'

I thought of having to traipse up and down Oxford Street going into every store until we found material of exactly the colour I had in mind. And shopping is ana-thema to me anyway. But I made the supreme effort and, with Avril, went into D. H. Evans: there, slap in the middle of the counter in front of the main entrance, was an enormous roll of exactly the right material in precisely the right colour—as though put there by God himself. He'd obliged by putting it in a sale, too, which helped to save the pennies! Back home, Avril ran the costume up in one evening.

There were now only three weeks to go and I had al-ready received details of where to park my car for the Consecration Service. And I hadn't started the picture! I

was waking up in the middle of the night with nightmare visions of the Chaplain General consecrating my painting in instalments and saying, 'Come back next week and I will consecrate a bit more.' The night before I was due to start the painting, we had invited a very dear group-captain friend of ours and his wife to dinner and I never said a word. I was ill with worry. When he said goodnight, he made a remark which remains one of the most significant things ever said to me: 'Don't worry, David. I know you're worried sick about that picture, but you're going to have some sort of religious guidance painting it.' It was sincerely meant. And I honestly believe I did have that guidance. The painting, as I have said, fell off the brush like nothing I have ever painted before or since.

David Winter arrived early next day. And I painted him in five days. He stood absolutely still and as rigid as a rock; I knew from experience what hard work that can be. On many occasions when I was training with Robin, he had used me as a 'clothes horse', which did at least show me the business from the other side. I had once sat for days wearing the silk robes of a university chancellor for a portrait he was painting. And I knew that if you put your arm up to have a scratch, and put it down again, all the folds in the silk would be different. Standing is even harder. David stood on that dais while I painted his costume in one go, a session that lasted nearly seven and a half hours. I had almost to chip him off the dais when I finished and we both dropped in a heap. I feel strongly that his dedication to that painting played a very important part in its success. There was a lighter side to it all. Our children, quite young at the time, inevitably got to know David as Jesus. Any attempts I might have made in my limited way to give them religious instruction were hopelessly undone because, as they used to say when they went to school, 'We've had Jesus to tea.'

The painting portrayed Christ in bare feet. I had never painted feet in my life, and had only painted hands on one occasion. David had magnificent, massive hands; I painted him holding them slightly out to give just that little bit of animation, desperately trying to avoid the supplicating, sentimental effect of so many Sunday School pictures. On either side of Christ I had to portray soldiers of different historical periods praying on a war-shattered hillside. These wore the combat dress of pre-1910, World War I and World War II. And there was to be a field chaplain symbolically taking a service on the battlefield. The third stage of the painting consisted of twenty totally unrelated little military cameos, each one representing a different regiment that had been stationed at Bordon: REME, with their Saracen and Ferret armoured cars, Bedford 3-tonners and Land Rovers, sappers building a Bailey bridge in Normandy, the Military Police with an Alsatian guard dog, the ATS with their tin hats on, manning a radar set in the Battle of Britain, the Medical Corps with a field hospital, the RAOC going to war in Flanders with their London buses, World War II tanks, World War I field-guns, airborne troops jumping out of a Horsa glider in Normandy. All had to be represented in their individual episodes. It entailed an enormous amount of research and many hours spent with my chums in the reference library of the Imperial War Museum, and it all had to link up with the central figure of Christ.

With just a few days to go before the Consecration Service, the painting was finished. While the canvas, 15ft by 18ft, was still wet, the framers had to take it off its stretcher to get it out of my studio. Three chaps were placed along the top and three at the bottom, and the idea was that they would pick it up gently to form a U-shape to get it out through the door. The 'U' in fact immediately took the form of a sharp 'V' and a crack started running right across

the middle. However, there was no turning back. We got it outside and put it in the removal van. For the journey, it had to be roughly put back on its stretcher again. And off we went to Bordon, where the second nightmare began. The stretcher had to be assembled inside the church. So the canvas came off once again. For a perfectly horrifying half hour that wet canvas lay face upwards on the path outside the church while the stretcher was reassembled inside, behind the altar. Thank heavens it was a sunny day. I prayed for an umbrella every time a pigeon flew over, but fortunately those round Bordon seemed fairly well house trained.

The painting was duly reassembled on the stretcher behind the altar, and a few last-minute touches made. It speaks well for the canvas and the paint, and my nerves, that no damage was done.

So the day of the consecration arrived. All the brass hats arrived and the church was full of important people. The service was very moving. My mother and Avril were with me in the front pew and I was moved to tears, quite unashamedly, as the Chaplain General raised his arm and consecrated my very own painting. After the service, when the guests had gone off to the tea tent, the Chaplain General and myself were left alone in the church. 'Now, come on, David. Tell me all about this picture.' He told me it was one of the best religious paintings he had seen. Then he said, 'Aren't you the chap who usually paints elephants?'

I thought, 'My godfathers. I can't even get away from them in church!' He asked if I was going to paint any more reredoses. I said I didn't know, and he immediately replied, 'If God tells you to do some more, you have got to do them.' We left it at that, and so ended a very happy day.

That commission means more to me than any other I shall ever paint. The nightmare moments which accom-

panied it are all memories now, but I do believe that the more heartache and mental effort one puts into a project, the more successful it is likely to be.

Another commission that brought hilarious moments came from the Anglo-American Corporation, who wanted a portrait of His Excellency the President of Zambia, Dr Kaunda, to hang in their headquarters in Lusaka. To begin with, BOAC lost the canvas and the frame on the way out to Lusaka. But this always happens when I fly anything abroad and was a small problem compared with some of those to follow.

One normally needs a minimum of five days to paint anybody. And the more important the person is, the busier he is and the less able to afford the time. When I arrived in Lusaka, I had a preliminary talk with the Anglo-American people. They were restrained in their comments, but seemed a little dubious as to whether I would be able to get KK—as Dr Kaunda is known to all his friends—on his own for that length of time. I had known him since Zambia's independence, and as he happened to be on holiday in the Luangwa Valley National Park at this time, I saw the possibility of being able to paint him out in the park itself, undisturbed by affairs of state. It seemed an unfair thing to do because KK has almost no chance to relax and his greatest moments of joy are spent watching wildlife. But it had to be done.

I flew out to the park with Avril and met KK. He, typically and generously, said he would sit for as long as he possibly could, but even here he was attending to state business. He thought he would be able to spare me about a day and a half. Once again my nerves started taking a beating, and I hardly slept the night before I was due to start. The problems of painting a head of state in a day and a half, in a national park, were unusual. First of all, when you stand to paint a portrait, you have to have the

sitter at eye-level. This means that you must put him on a platform, and platforms are not usually found in national parks. There was no time on the morning of the first day to go into any of this in detail—KK himself suggested that we took the wheels off a bulldozer! We did so and he climbed up into a Woolworth's aluminium chair perched precariously on top of them. This gave me the required height.

Then came the matter of a shirt. KK is a marvellously informal person and I remember rummaging around in his suitcase with him, looking at the shirts Betty Kaunda had packed for him. I didn't like any of them: I really wanted a dark green one. The only one available was the one I was wearing, so we swapped and I painted him in my shirt.

So we began, in a temperature of about 100°F, my sitter perched under a tree with a transistor radio for company. The problems got worse as I progressed. As the sun moved, I found to my horror that the shadows across his face changed as fast as I tried to catch them. I tried desperately to hide my worries but I am sure KK sensed the unease. We chatted informally about everything under the sun, and he did all he could to soothe my tattered nerves.

Hippos were making revolting noises in the lagoon just behind us, and then an elephant walked across my view in the background. As if that were not enough, people kept rushing up with state papers for him to sign. The whole situation seemed unreal, like a peculiar dream. And KK would much rather have been watching wildlife.

In the impossibly short time available, I achieved about 10 per cent of the portrait, a sort of rough, quick flash of KK. In this state of panic I decided that, in the last hour of the last morning, I would turn the canvas sideways and do a quick colour note down in the left hand corner. So I

started painting him all over again. The idea was that I would use these quick sketches, aided by photographs which it was agreed I would take in Lusaka, and paint the proper finished portrait when I got back to England. So we parted happily and good friends.

Back in Lusaka, Anglo-American wanted to know how we had got on. In the boardroom, Avril and I were confronted by the chairman and the board of directors.

'It's been a bloody disaster!'

They did not express too much surprise. 'Well, we could have told you that before you started, but we didn't want to worry you. We didn't think you had much chance of getting any time at all, but let's have a look at it.'

I politely declined, but they again requested to see it. I explained that as I had only really achieved a quick colour note I proposed to do a proper finished portrait at home. They forced me to show it to them. There was a long silence for what seemed like twenty minutes. I was beginning to feel sick. Then, after a lot of whispering, came the comment: 'That's the best portrait we've ever seen of the President. We'll have it just as it is.'

This put me in a frightful dilemma. My professional instinct told me that I must either do a proper portrait or work on this one to make it reasonably presentable. In any case, I had told them already that it was a 'bloody disaster'! To their great credit, they said, 'We don't want a stuffy boardroom portrait of the President. Here you've achieved something fresh, which you'll never get if you go back to London and do a chocolate box.'

'At least let me wipe the other face off the bottom left-hand corner.'

'If you go back to where you are staying in Lusaka, and work on it and bugger it up, we won't have it.' That seemed fair enough. After all, they knew what they wanted and they were paying for it.

I was torn two ways. Avril kept whispering in my ear, 'If they want it like that, let them have it.' But I won the day. Every picture an artist paints has a point of no return —beyond this any work done on it is retrogressive. In this instance, the temptation to 'work on it' was almost impossible to resist. But firmly I wiped off the second KK and cleaned up the canvas just a little, desperately hoping to retain the apparent freshness that I had, according to them, achieved. I delivered it the following day and they were fully satisfied. That portrait proved conclusively, I think, that by working under extreme pressure and in seemingly impossible conditions, a spontaneity may be achieved which can never quite be attained when painting in the studio.

The conditions in which I painted Sheikh Zaid of Abu Dhabi were equally mad. I must have anticipated with some sort of sixth sense that disasters were going to be inevitable, because I quoted a very high fee to cover everything that might happen, and everything did.

Sheikh Zaid is a fine man who is most generous to his people. He does not speak a word of English, but he knew about me and especially wanted me to paint him. In the initial stages, what seemed like a flood of letters went backwards and forwards over a period of about five months between his ADC and myself, trying to fix some definite arrangement. I had asked specifically for a minimum of five days for the sitting. It was finally arranged that I would fly out at the beginning of February. This, I was told, was the best month for Sheikh Zaid. So at Heathrow I hopped on a Kuwait Airways 707 with my easel and paints, expecting to be met at Abu Dhabi. In those days the place was still pretty undeveloped and the airfield was in the wilderness. We landed there at 4 am, and I got off feeling pretty miserable, and watched as—inevitably and quite expectedly—the 707 of Kuwait Airways went

on to Karachi with my easel, my frame, my luggage, my toothbrush and the canvas. I was left standing on the airport with only what I stood up in. No one was there to meet me. If ever I felt like packing it all in, this was the moment. Moreover, I didn't have a visa, so they wouldn't let me in. I had tried desperately to get one in London but was unable to and rather than delay the whole thing, I had taken a gamble. Now I just wanted to sit down and cry.

I knew that the Trucial Oman Scouts—a group of War Office-paid British officers and men seconded to serve in the Trucial States—had a camp and an officers' mess about two miles away from the airstrip where I was now stuck. I had done a painting for them three years previously. There was a telephone on the immigration officer's desk. In my desperation I must have muttered something that sounded like a request in Arabic. Anyway he seemed quite friendly and, jumping in with both feet, I rang the officers' mess. As luck would have it, although it was by now 4.30 am they were in the middle of what was obviously a boozy mess party. I could hear it going on in the background. Nevertheless, it must have sounded slightly unreal for them to hear a voice calling himself David Shepherd and saying he desperately needed a bed for the night. But the army are unbeatable on such occasions. Over the telephone came a slightly drunken voice, 'Christ Almighty, what the hell are you doing here? Come up and have a drink.' I briefly described the predicament, and a few minutes later a Land Rover came shooting up to the airfield in a cloud of dust. I was saved. They gave me a bed for what was left of the night, and in the morning I got hold of the ADC to Sheikh Zaid and asked what the hell had happened. Out in the Gulf in the heat, nobody really gets excited about anything, except me. 'Oh, sorry old boy, we thought it was next month you were coming.'

After three whole days—which, of course, is nothing in

the desert—the airline kindly returned my baggage from Pakistan, complete with toothbrush. It was then agreed that we would try and retrieve something from the wreckage of the commission. So I was driven to Buraimi. I suppose the oil sheikhs have to spend their oil money on something, and we drove down this amazing tarmac dual carriageway straight into the desert, with street lighting most of the way down; otherwise there is nothing else except sand. The journey took about three hours and, when we arrived, the ADC trotted off to Sheikh Zaid and came back with what seemed to be the encouraging news that I was to be granted an audience at 9 o'clock the next morning.

At sunrise we set off to drive 20 miles to the house in the desert where I was to meet Sheikh Zaid. My spirits were skyhigh as we arrived. The house stood in the middle of nowhere, with palm trees around it and a few camels chewing whatever it is that camels chew. One almost expected Rudolph Valentino to come round the corner. But I began to have a sinking feeling that all was not well. Instead of finding Sheikh Zaid ready to welcome me, there were 198 Arabs all waiting to see him! I know there were 198 because I had four hours in which to count them. I was invited to sit down on an enormous mat in a sort of huge anteroom which ran right round the house like a verandah. It turned out that indeed an appointment had been made for 9 o'clock, but everybody else had the same appointment! So everyone sat quite calmly, except me, until 1 o'clock in the afternoon. Arabs do not get upset by delay. This part of the world appears to be timeless.

The people had walked or ridden their camels in from the outlying districts to tell their stories to the head of state. They were perfectly happy to sit there all day, and the next day if necessary, smoking their hubble-bubble pipes. And an Arab does not think he is being rude if he

keeps you waiting seven or eight hours for an appointment. It is not rude to him—as time means so little, patience is a virtue. Some time between when the sun comes up and the sun goes down will do. If he misses one day, the next will be just the same. Actually they do have a point there. Maybe this philosophy is one I should try to adopt.

At about 3 o'clock, by which time I was nearly asleep, Sheikh Zaid arrived in his Mercedes. He sat down with all his countrymen, but nothing happened. There was no hurry. Even the flies got drowsy in the heat of the afternoon.

One by one, as if by some hidden signal or intuition, members of the throng would sleepily get up, wander over to Sheikh Zaid and exchange a few whispered words. After a few more hours, when the flies had stopped buzzing altogether, he rose to his feet, got into his Mercedes and drove off over the sand. End of day one. I had not even said, 'Hallo'. The next day the same thing happened all over again. But it was at a different house, for variety. And this time I couldn't be bothered to count all the other Arabs. Day three dawned. Once again time continued on its quiet, unruffled way with Shepherd doing exactly the opposite. My nerves were by now beginning to get tattered at the edges, and I wondered if I was going to meet him at all.

Sheikh Zaid spent quite a number of nights away from the royal palace in Abu Dhabi staying at houses in various oases out in the desert. After a great deal of detective work, we managed to track him down on day four. With Sir Hugh Boustead, who was looking after me and trying to control the rapidly deteriorating situation, we stood in front of the Mercedes to stop it going any further. Sir Hugh had a chance to talk through the window of the car and tell Sheikh Zaid that I was in fact there. And it was

arranged that I could definitely meet him the following morning in the gardens of the town.

I dutifully turned up at 11 o'clock and once again the hours ticked by until late afternoon. Obviously day five was going to be the same as its predecessors. And so was day six. But the gardens were shady and pretty.

Day seven and the situation was now absurd. I would have to do the portrait from photographs. On day eight Sheikh Zaid actually came into the gardens, surrounded by a retinue of servants, all looking very biblical. Sheikh Zaid has the most amazing presence. He graciously shook my hand, then sat down on the grass and immediately got into an animated conversation with Sir Hugh Boustead. They have known each other for years and are great friends.

By this time I was in a state of near-panic. All I could do was point the camera in roughly the direction of Sheikh Zaid while he was talking—and I prayed hard. There is, I believe, a complication called 'parallax': if you put the lens too close, you cut off the top of the subject. It seems that this is what happened, because when I got the transparencies back from Kodak, I found that in thirty-five of the thirty-six exposures I had cut off the top of Sheikh Zaid's head! But the last transparency was a fairly good one and I did the entire portrait from that. The painting now hangs in London in the Abu Dhabi Consulate. I am told that Sheikh Zaid is very pleased.

Painting the Queen Mother must always remain one of my most enjoyable assignments. Although I have never been very happy about painting women, I knew that the chance of being asked to paint royalty comes perhaps once in a lifetime to a very small number of portrait painters.

The painting was commissioned by the King's Regiment, and I first met the Queen Mother when she was presenting the regimental colours at Catterick. This was

just a very formal and quick 'hallo' and handshake. But she knew about the commission and a meeting was arranged at Clarence House to talk about pose, costume and the rest of it. It turned out a relaxed and amusing meeting — such is the complete informality of my favourite member of the Royal Family that you are put at your ease immediately. But I created, I believe, the usual confusion that always seems to follow me wherever I go.

First of all, I was determined to try and get away from the set, conventional royal portrait. I think that when royalty, or anyone else for that matter, is all decked out in crown and jewels, wearing a full-length evening dress covered in orders and ribbons, and perhaps standing by a gilt armchair in front of a huge mirror, the face of the subject shrinks to the size of a small saucer. One is dazzled by everything else in the picture, even when the sitter is painted life-size on a 6ft canvas. When the artist is commissioned by a certain regiment or military station abroad, he is often requested to put representative little cameos of Malta or other itsy-bitsy scenes in the background, and this doesn't help either.

So I decided to break away from all this and paint the Queen Mother in the day costume that she wore when she went to Catterick to present the colours to the King's Regiment. And there would be no little bits of Catterick or any other regimental scenes in the background if I could help it.

So at that first meeting at Clarence House I put forward my ideas to the Queen Mother and the proposal, thank heavens, appealed to her at once. 'Oh, I remember, I was wearing that turquoise feather hat, wasn't I? I'll just go up and get it.' She came downstairs with it on her head, and that particular day she was wearing a pink dress, so I now have some rare, colourful pictures of the Queen Mother which even Cecil Beaton hasn't got.

The next matter to discuss was the room where I was to do the painting. I was taken up into an enormous drawing-room full of priceless furniture, and there, in the very darkest corner, already set up and ready, was the Clarence House easel. Each royal household apparently has its own easel, because there is a constant queue of artists waiting to paint whoever lives there. And how they must suffer. Anyway I was gently but firmly informed that 'this was where I was to paint Her Majesty'. I wondered if I was expected to say 'Yes sir, of course'. But I am afraid I didn't. I said I was sorry but I couldn't paint anybody in that corner because I wouldn't be able to see my subject.

'But that is where Annigoni painted Her Majesty, and that is where Augustus John painted Her Majesty before him.'

I have a slightly jaundiced opinion of many royal portraits that have gone before: possibly the reason why they didn't turn out as well as they should have was that the artist couldn't see what he was painting! I pointed this out as diplomatically as I could.

The Queen Mother now joined us. 'Is Mr Shepherd being difficult?'—or words to that effect. 'Yes.' But it was all fun and my protestations worked. I was given a conducted tour of Clarence House in search of a room where I might actually have some daylight. I didn't think I was being too unreasonable; for a decent job I should have the best facilities possible. Finally we came to a lovely garden room overlooking the Mall, with the sun streaming through the window. It was full of flowers and a lovely soft atmosphere. I immediately started jumping up and down with excitement explaining that this room 'will do me fine'. The Queen Mother seemed at this stage to be just a little worried. It appeared that there was to be some large buffet lunch in the room the next day, but as far as I remember the guests were shifted somewhere else. The

easel was duly placed in the garden room and so began the series of eight sittings spread over four months.

We talked incessantly throughout each session; the atmosphere could not have been friendlier or easier and it was often hilarious. I believe it was Africa that did it. 'Winnie said to my husband and myself that we must go,' the Queen Mother said, referring to their first visit in 1923 when they went to Uganda, where the Queen Elizabeth Park is named after her. After the last session, the Queen Mother told me I had reminded her of so many happy days she had spent in Africa with the late King.

For each of my eight sessions I would arrive at 11 am on the dot. The back door, which everybody appears to use, opens straight on to a very narrow gap between Clarence House and the next building in this quiet corner of St James's. There I used to park my estate car, blocking the alleyway, and unload. Out would come the folding paint-box, paints and all the paraphernalia. And exactly on the stroke of 11 o'clock, in full swing would come the Guards, playing, on their way to the Changing of the Guard ceremony. And Shepherd used to cause confusion as the bandsmen tried to squeeze past his car in the gap. I would get jocular and sometimes slightly obscene comments muttered at me through the trombones as they squeezed by—but they always succeeded in continuing to play as they did so. I could not very well keep the Queen Mother waiting, although on one occasion she herself was late. She breezed in with the delightfully informal comment, 'I am sorry to keep you waiting, Mr Shepherd. I have been up the road having coffee with my daughter.' Who was I to complain?

The day before one of my Clarence House sessions I was lying on my back scraping muck off the underneath of *Black Prince*. On my return home Avril had pushed me

straight into the bath and told me to soak all night—but the Queen Mother never knew.

We talked about everything under the sun, from long-haired youth to modern architecture; she shared some of my own pet hates. As we looked out of the window from Clarence House, we could see the monolithic ugliness of high-rise blocks ruining the lovely skyline around St James's Park. And the Queen Mother came up with the interesting and delightful theory that if you stood upside down and looked at the landscape that way, you tended to notice only the nice things, such as the trees. So we discussed the situation looking sideways, and almost upside down, out of the window.

When the day came for the last session I was asked to stay for lunch; the invitation came down in the form of a scribbled message in pencil on a piece of lined notepaper. I had been working there in my painting jeans and old shirt, but I thought that for this occasion I had better tidy up. As the Queen Mother came in for the last time, she expressed surprise to see me dressed in a suit. 'Yes, but Ma'am, you've invited me to stay to lunch.'

'But it is only you and the Duchess of Gloucester. You need not have bothered to change!'

Among other portraits that have meant a great deal to me was the one of my headmaster that I painted for Stowe School. And then there was dear old Rambo. We have a thatched fisherman's cottage on the cliffs in Cornwall to which, in theory anyway, we endeavour to escape sometimes from the telephone and the 'box'. And in the village lived Rambo, one of those marvellous old Cornish lobster fishermen who seem to live in another age. The people have considerable reserve down in Cornwall, but once you break through they are, of course, as warm and friendly as anyone else. Rambo had the sort of face and personality which I felt was God's gift to a portrait painter. His very

complexion breathed the salt spray in which he had lived for seventy-six years, so I took my courage in my hands and knocked on his door to ask him if he would sit for me. In my patronising ignorance I went into a great long speech about what hard work it would be, that it was not just a matter of sitting and being painted, and that I must pay him for his efforts, and so on. When I did allow him to speak, he pointed out that he had 'sat for fourteen artists last summer and sixteen the summer before that'. He came into my cottage and sat patiently smoking his pipe and chatting. He told me of the early days of sail, and launching the lifeboat into the surf and then rowing out into the storms to the sailing ships which met their end on the Lizard peninsula. I wished I had a tape recorder there.

Apart from the Queen Mum, who was heaven, and the po-faced débutantes, who were hell, the only other member of the fairer sex I have painted is Avril. And this was when the poor girl had mumps—and time to spare. I dragged her out of bed and propped her up in the studio for a week in the freezing cold. The result looks like it, and that painting has been banished into the cupboard below the stairs. But the second portrait of her turned out better.

11 GIANTS ON FILM

'The Man Who Loves Giants' and fun with the BBC—walking up to jumbos with an easel!—I learn a sharp lesson, and lose a good friend—a final ambition

It's surprising how many people, when they come into my studio and see a jumbo on the easel, say: 'It looks just like a steam engine.' So it isn't just me: these two giants that I love so much do have common characteristics. Each has power, drama and the ability to send me into ecstasies.

In 1969 the BBC decided that these two passions in my life might be worth putting on film. So they made a ten-minute, black-and-white film for children's television. At the same time they intimated that they 'might make this into something bigger'. And so was born *The Man Who Loves Giants*, a fifty-minute, colour documentary made by BBC Bristol and first shown in 1972 in 'The World About Us' series on BBC2. It was then repeated, and later shown on BBC1, on Christmas afternoon. Since then I cannot imagine how many people have seen it, as it has been screened in almost every country, including the United States of America. We were lucky to have James Stewart to do the narration. Jimmy is a great conservationist and a good friend of ours, and his famous voice lent just the right note to the commentary.

It took six weeks to film the nine hours of material. And this was an often hilarious and always happy time for all of us in the family—and, I'm sure, for our six chums from the BBC. We got off to a marvellous start right away. We put up the whole film unit in our house and got to know each other very quickly. The cameramen took the kids to

school while the electrician did the washing up. And I am quite sure this happy feeling reflects right through the film. We clicked as a team and the whole thing was beautifully knitted together by Chris Parsons the producer, who knew exactly what he wanted. We filmed in a number of tricky and delicate situations, and I can get very temperamental. But his always friendly but firm control over the whole proceedings enabled him to portray the many facets of the life I am fortunate enough to lead, and the whole thing went without a hitch from start to finish.

To begin with, we worked for three weeks in England. The central theme running through the film, linking it together, was to be the painting of the five wildlife pictures I was undertaking at that time to raise money in America to buy the Bell Jet Ranger helicopter for Zambia's Game Department. I was about to start the major one of the five paintings, a 6ft jumbo painting. With a camera pointed over my shoulder for a number of days, the film unit succeeded in getting the progression of the painting from blank canvas to completion. Then we all went over to America to film the auction of the paintings and the successful raising of funds to buy the helicopter.

To cover the part of my life when I painted for the services, we chose the most spectacular subject—the in-flight refuelling commission that I painted for the Royal Air Force. For this we flew with the camera crew in a V-bomber and it was 90 Squadron, at RAF Marham, who gave us all the facilities. Indeed, as far as I remember, we more or less took over the whole squadron for three days. The RAF are magnificent on occasions like this; it is, of course, marvellous publicity for them as well, and the Victors were given a special clean and face-lift. We had two Victor V-bombers at our disposal and the resulting film is one of the highlights of the documentary. This was probably the first time that the in-flight refuelling proce-

dure had been shown on television. It is a beautiful sequence in colour, almost like an aerial ballet.

While up at Marham, we took the opportunity to recreate the days in the early 1950s when I began my career at London Airport. And, with the clever insertion of library film of Constellations and Stratocruisers, the illusion was successful. I always seemed to paint in a howling gale at London Airport—the easel often had to be weighted down with a car jack—and to simulate these conditions, the station commander's light aeroplane was brought into use. Whilst I was filmed painting, the Chipmunk was just out of camera behind me and I was in the slipstream. Fun was had by all—particularly the station commander, who very nearly blew us all off the airfield when he brought the engine up to full power!

I was particularly delighted when the BBC agreed that we should incorporate a sequence featuring my portrait of Christ at Bordon. We filmed live at a Sunday-morning service, and I don't think the little church has ever been so full before or since. Of the very considerable number of letters I received after the screening of *The Man Who Loves Giants*, the majority made particular reference to this sequence. And, incidentally, when I was on the radio programme 'Desert Island Discs' and had to choose eight gramophone records, I made mention of this painting of Christ. And there was the same response.

We made another evocative sequence at the railway scrapyards down in Barry, Glamorgan, where the BBC took some beautiful shots of the rotting steam engines. Here, we simulated the purchase and restoration of my engine No 75029.

We then moved out to Africa for three weeks. At Germiston steamsheds, outside Johannesburg, some more marvellous film was taken. I set up my easel outside the shed, surrounded by the enormous steam giants of the

South African Railways, and, as always, got carried away with excitement.

It was in my beloved Luangwa Valley in Zambia, which I consider to be the finest national park in the whole of Africa, that we obtained what must be to many people the highlight of the film. As far as I am aware, no artist has ever carried a full-sized studio easel and canvas up to a group of wild elephants and painted them from life—certainly not with a film team.

Over the past twenty years or so, I must have been out on countless occasions, on foot, into the bush, watching elephants. And I have done it with a number of different people. Some fill you with confidence and some don't. Some show off, and this attitude of bravado, or ignorance, can so easily end in fatal results. On one occasion I stood, with the person taking me out, in an area of completely empty bush, without even a small tree, and we were charged by a very angry bull elephant. For once my better judgement prevailed and I stood firm. But I do remember the person standing beside me, who was unarmed, calmly saying, as the elephant came at us like a steam locomotive, 'Don't worry, he'll stop when I shout.' He did. If he hadn't, I would not be writing this story now. Generally, if you leave a wild animal alone, it will avoid you and leave you alone, and elephants are the most wonderfully benevolent animals if left in peace. However, there is always the element of danger in the unexpected. All too often these days, in central Africa, elephants have been filled with lead shot from poachers, or poisoned arrows, or bullets from freedom fighters or the army; elephants have even been known to tread on land mines. And for every good reason, these elephants are not so benevolent. One must prepare for all eventualities. So I knew that if we were to make this sequence for the film in reasonable safety we would need to have Johnny Uys and Rolf Rohwer to look

after us. They were my two greatest friends working with wildlife. Rolf managed to take time off from his safari firm, and Johnny, at that time head of the Game Department, did not need any persuasion to leave his desk and return to his beloved Luangwa.

It was Johnny who had taken Avril out into the bush while I was painting Dr Kaunda's portrait in the Luangwa Valley. And she has never forgotten those four days. Johnny's knowledge of nature was almost limitless. According to one famous story, he was returning from a long, meatless period on his own in the bush, when he came across lions on a freshly killed buffalo. Johnny was hungry, so he frightened the lions off and took a leg from the carcase for himself. He was an inspiration to everyone and, like Rolf, was not only a great friend but a wonderful person to be with in the bush. For good measure, we also had Nelson with us. He was the Chief African Ranger with one of the big safari organisations in Zambia, and was famed throughout the country for his bushcraft and immense knowledge of wildlife. He was probably as good as Rolf or Johnny in a tricky situation.

If an artist decides to walk up to a jumbo with an easel —which, let's face it, is a crazy thing to try and do—it is of paramount importance that the elephant is unaware of what is going on. Once it becomes the slightest bit suspicious, any further attempt to go forward is quite pointless. Elephants have poor eyesight but acute hearing and a good sense of smell. So absolute quiet is essential during the approach—and, of course, the wind should be reliable.

So the procedure would be to set the canvas on the easel, with the paint all ready on the palette, and sit with the apparatus in the back of an open Land Rover. Rolf or Johnny would drive and, when they saw a group of elephants perhaps half a mile away, basking placidly under

a tree in the heat of the day, they would lean out of the cab and ask, 'Will they do?'

'They look OK to me. Let's have a go.' We would then stop and hide the Land Rover in the bush. And so would begin the long, hot stalk, for up to half a mile. Any distance shorter than this would have been insufficient as the elephants would have heard our approach.

The temperatures in the Luangwa might be up to 120°F. My easel was no small sketching one, but of studio size, and the canvas measured 36in by 24in. I had to carry the thing in the air, otherwise the telescopic legs, which had already been extended, would have caught up in the undergrowth and the elephants would have heard the bottles tinkling together and been scared off. Rolf or Johnny would lead, with rifles cocked, just in case, and I would follow holding my easel above my head. Avril would be behind with Chris and the cameraman, and Nelson would bring up the rear.

One 'walk' was particularly amusing. An old bull jumbo was ambling along a bush path, minding his own business, and we decided to try him for size. But he wouldn't oblige by stopping, and it must have looked incredible to see a large bull elephant ambling along the trail followed by a long train of people, one carrying an easel above his head. He wandered on and on. Finally, Rolf whistled at him to wake him up. It shook him out of his skin, and he trundled off into the bush. That was one elephant that clearly was not going to have his portrait painted.

But on more successful occasions, when we got within fifty yards or so of the unsuspecting elephant, Rolf would stop us with a silent wave of his hand. Then he and Johnny, with myself and the cameraman, would stealthily creep nearer until once again came the signal to stop. Once or twice we got to within thirty or forty yards of the jumbos. And I would put my easel down very quietly and

gently, walk around it, pick up the palette and start painting, with Rolf and Johnny squatting by my side. If the wind is reliable, one can get away with the seemingly impossible. The only sound to be heard would be the gentle purr of the movie camera behind me. And in this way we got some magnificent movie film which must surely be unique.

People behave in different ways when confronted with sticky situations concerning wild animals. At the time I was painting Dr Kaunda's portrait, Johnny had taken the President, his personal staff, Avril and myself out one evening to watch wildlife. We saw a rhino asleep under a tree and Johnny took the president and myself fairly close up to it.

'David, do you want to go closer?' I assumed Johnny was asking me and not the President because I was more expendable. I agreed that I would like to have a go, as the rhino looked fairly placid. 'What do I do if it comes for me?'

'Stand still, and don't run. I repeat, don't run.'

Full of bravado and too much confidence I walked up as close as I was allowed. Nothing happened. The rhino remained looking at me, but he was in a good mood. I came back to Johnny and the President. I wanted to find out how, in the opinion of the expert, I might have behaved if the rhino had come for me : 'Would I have stood still as you told me?'

'Not a bit of it, you'd have been up the first bloody tree before you even knew it!'

This bears out the stories I have heard. If you have an elephant coming at you full pelt, they say you are up at the top of the tallest tree for miles before you think—even if you have a wooden leg!

On one occasion while we were filming, a cow elephant must have heard some slight sound and become suspi-

cious. She charged, and it was Rolf who saved our lives by shouting at the elephant and stopping it dead in its tracks. This gave Avril and the rest of us time to get back to the Land Rover. It was a nasty situation to be in—Rolf told me afterwards that if the elephant had taken one more step, he would have had to shoot her, upwards. When we reached safety, I started shaking with excitement and laughter. And it was then that Rolf gave me a well-deserved reprimand. He reminded me that such animals are wild and you cannot take liberties with them. 'I'm going to give you one hell of a fright next time you come back to Zambia—and teach you a lesson.' I have that pleasure to come.

But all this has a tragic ending. Two of these three marvellous people with whom we filmed *The Man Who Loves Giants* have since been killed by wild animals. Johnny Uys, in spite of his vast experience and knowledge, must have taken just one liberty too many, or perhaps he got that little bit familiar with his beloved jumbos. He was taking a party of tourists out on foot, in Rhodesia. Johnny walked on ahead, up to a herd of cow elephants. He apparently did not notice a lone cow on her own in the deep undergrowth. She came out of the bush at him, in a full-blooded charge, with no warning. He saved the life of his tourists, but it was too late for Johnny. She killed him with one sweep of her tusks.

Johnny's ashes are scattered in his beloved Luangwa. And I have lost one of my greatest friends. A few months later, Nelson met his end in unexplained circumstances. He was found dead beside the body of a buffalo.

And so this film is tinged with a hint of sadness for me. And I don't think I shall walk up to any more elephants with an easel. But in spite of this, the film reflects my whole marvellously exciting and wonderfully full and happy life.

Today I work from one exhibition to another, in Lon-